Plotting the Novel

EX LIBRIS

Also by Michael Legat

novels
Mario's Vineyard
The Silver Fountain
The Shapiro Diamond
The Silk Maker
The Cast Iron Man

non-fiction
Dear Author . . .
An Author's Guide to Publishing
Writing for Pleasure and Profit
The Nuts and Bolts of Writing
How to Write Historical Novels
The Illustrated Dictionary of Western Literature
Putting on a Play
We Beheld His Glory
Understanding Publishers' Contracts
Non-fiction Books
An Author's Guide to Literary Agents
Revision: An Author's Guide

Plotting the Novel

Michael Legat

ROBERT HALE · LONDON

© *Michael Legat 1992*
First published in Great Britain 1992

ISBN 0-7090-4770-3

Robert Hale Limited
Clerkenwell House
Clerkenwell Green
London EC1R 0HT

5 7 9 10 8 6 4

Photoset in North Wales by
Derek Doyle & Associates, Mold, Clwyd.
Printed in Great Britain by
St Edmundsbury Press Limited, Bury St Edmunds, Suffolk
and bound by
WBC Book Manufacturers Limited, Bridgend

Contents

Acknowledgement

Acknowledgement is made for permission granted by A.P. Watt Limited on behalf of Timothy d'Arch Smith to quote a passage from Pamela Frankau's account of her writing life, *From Pen to Paper*. The book was published by William Heinemann in 1961.

1 *Plots and Stories*

Definitions
What is a plot? One definition says, 'A plot is just something you hang ideas on', but that seems to me less than helpful, unless you happen to be one of those novelists who want to put across to their readers a message of some kind, and who work out a story for the sole purpose of enabling them to do so as effectively as possible.

A more down-to-earth approach would be to say that a plot is nothing more than a story. But is it really as simple as that? Perhaps not quite. In which case you might ask just what the difference between 'plot' and 'story' is.

E.M. Forster in *Aspects of the Novel*, a book based on a series of lectures which he gave at Cambridge, explains the basic difference. (Incidentally, if you find it difficult at first to understand exactly what he is getting at, do not despair – it becomes clearer as he goes on.) A story, he says, is 'a narrative of events arranged in their time-sequence – dinner coming after breakfast, Tuesday after Monday, decay after death, and so on ... it can only have one merit: that of making the audience want to know what happens next.' On the other hand, 'a plot is also a narrative of events, the emphasis falling on causality. "The king died, and then the queen died" is a story. "The king died, and then the queen died of grief" is a plot. The time-sequence is preserved, but the sense of causality overshadows it. Or again: "The queen died, no one knew why, until it was discovered that it was through grief at the death of the king." This is a plot with mystery in it, a form capable of high development. It suspends the

time-sequence, it moves as far away from the story as its limitations will allow.'

Forster now clarifies the point by continuing: 'Consider the death of the queen. If it is in a story we say: "And then?" If it is in a plot we ask: "Why?" That is the fundamental difference between these two aspects of the novel ... a plot demands intelligence and memory also.' In other words, a plot looks for the background to the narrative of events and the motives of the characters who appear in it (which means inevitably that it explores those characters in some depth), things happen as a result of something else happening previously, and almost always, because it does not simply tell what happens next in a straightforward time sequence, a plot raises questions in the reader's mind and presents him or her with information which must be remembered because it is not fully explained at the time. A 'plot' is therefore very much more than just a 'story' in the sense that Forster uses the words.

We are, however, to some extent playing at semantics. If instead of choosing Forster's simple definition of the word 'story' we use it to mean the completed work, whether it is a short piece of two or three thousand words or a long novel, then we might say that the 'plot' forms the framework, the bones of the story. This is the substance of the two relevant definitions of 'plot' given in the Shorter Oxford English Dictionary: 'a sketch or outline of a literary work; the plan or scheme of a play, poem, work of fiction, etc.'

Forster's analytical approach and the dictionary's less imaginative definition are both valid. So a 'plot' can either be regarded as something more profound than a story, which will make quite heavy demands on the reader if it is to be fully appreciated, or it can be taken to mean the skeleton of a story, which may be quite simple or very complex and demanding, according to the flesh with which you intend to clothe it and the way that you propose to put that flesh on.

All this may be somewhat confusing, but whichever way you look at it, 'plot' is not a bogey word to be frightened of.

The Importance of a Plot

Is a plot essential to the success of a novel? Do all published novels have one? To answer the second question first, almost all published novels have some kind of a plot – it may be very slight, and on the surface it may sometimes appear that nothing of any significance happens (though in fact, since in novels of this sort characterizations are usually the author's main interest, there will almost certainly be a change or development in the characters, and that may justifiably be called a plot). Virginia Woolf is credited by some literary critics with having changed the course of the English novel away from the story towards a structureless form, with the use of the 'stream of consciousness'. Whether she originated this technique is debatable (James Joyce, for whom Virginia Woolf had little but contempt, might be considered to have a better claim), but this kind of almost plotless novel is usually 'literary', by which I mean that it is notable for its fine writing, its intellectual content and its seriousness. It may also be entertaining, but if so, that is a by-product, for it is not written simply to pass an idle hour on the beach or to while away a tedious train journey, to be read once and immediately forgotten. It is written because the author has 'something to say', and it makes demands on the reader – not least his or her full attention. It is not my intention to sneer at such books – indeed, I admire many of them greatly – but I doubt whether, if you are intending to write that kind of book, you are reading this one. It is far more likely that you are hoping to write what might be called 'a good read', and in that case the answer to the first question is that a plot is essential if you are hoping to sell your work (and most probably a plot of considerable strength).

The Complexities of the Plot

Reverting once more to Forster's definition, you may feel that, even if he was using it only as a basic example, 'The king died, and then the queen died of grief' is a pretty feeble plot, and that you would need a great deal more than that for a short story, let alone a novel. And you

would be right, of course, for, although there are always exceptions to the rule, we normally expect even a short story to have a certain complexity, while the plot of a novel in synopsis form may need several thousand words to cover adequately its ins and outs, its crises and their resolution, not to mention the characters, the sub-plots, the backgrounds and all the other elements which together make up the whole. If you were aiming to write a piece of fiction containing upwards of 45,000 words (which for most practical purposes can be taken as a minimum publishable length for a novel), you would expect to include in your story not only an account of the queen's love for the king, but perhaps the difficulties that she had encountered in their relationship; many other people would come into the story too – the rest of the royal family, the courtiers, and the queen's enemies, for of course we should need a 'villain' (as I shall explain later, I prefer the term 'antagonist').

Additionally we can say that plots should have a beginning, a middle and an end, that plots must contain conflict in some form or other (this is often where the antagonist comes in), that plots should be consistent within their own convention, that sub-plots should have a direct bearing on the main narrative, that plots should lead to an ending which will allow the reader to feel that justice has been done or that something has been achieved or that the principal characters have developed and changed (or perhaps that all three of these conditions have been met). And all this must be worked out with some sense of shape and narrative drive.

Formula Plots

The term 'formula' in relation to plots is usually heard in one of two contexts. Either someone talking about romantic novels is referring with contempt to the fact that they have 'formula plots', or a beginner is asking to be given the basic 'formula' for a plot, as though then all problems would be solved. Many novels – indeed, the majority – may be said to have a formula plot, whether it is the girl-gets-boy pattern of the conventional romantic

novel, or worthy-young-man-succeeds, or knavish-tricks-are-frustrated, or truth-is-revealed, or we learn whodunit and how and why, and so on. But while all these formulas may present some kind of starting point, they do not provide a magic key to plotting, and you will need to add a great deal more in the way of variations and complexities before you can feel that you have a workable plot.

The Artificiality of Plots

Neither in fiction nor in non-fiction can you take a slice of real life, and plonk it on the page in an unedited state. Non-fiction (and I am thinking particularly of biography, history, travel) might be likened to photography: 'the camera cannot lie', they say, but we all know that a photograph is taken from a particular angle, does not reveal everything about its subject, and is in fact selective; it *may* be an accurate representation, but it is much more frequently distorted to a greater or lesser extent according to the intentions of the photographer. Nevertheless, it must bear some degree of reality because of the technique involved. All that is true of most non-fiction.

Fiction, on the other hand, is more like a painting, in which the artist has much greater freedom than the photographer to present only those facets of the subject which serve his or her purpose, and to alter them in size, colour, texture and any other necessary way. Fiction is artificial to a high degree, so too are its plots. They do not consist of a slice of unedited life, but the material in them can and should be moulded to suit whatever your intention may be. Although contrived, they can reflect life fairly accurately – rather like a Gainsborough portrait, say – or they can be outrageously unrealistic – as in, for instance, the Cubist style – or they can lie somewhere in between those two poles.

Don't confuse credibility in fiction with real-life truth. Your readers want to believe in your story and to feel that its ramifications are logical within the conventions that you are using, but that does not mean that they will find any difficulty in accepting all sort of pretty extraordinary ideas, ranging from, on the one hand, a chemical drink

which can turn a respectable law-abiding doctor into a monster of depravity, to, on the other hand, rabbits and moles who are capable of human thoughts, emotions and behaviour.

The point is that when you write fiction you are creating something new, and you must decide how you are going to manipulate your story, what it is to be about, how it is to develop, where it is going to lead. It is up to you, not to anyone else, and you can please yourself entirely. There are, however, a few guidelines which you should respect: firstly, unless you want to write a story which might find its equivalent in an extravagantly non-representational painting, you should stick to one main theme; secondly, the plot needs to be comprehensible, so that it has a kind of cohesion, and its developments are logical; thirdly, nothing irrelevant should be included.

To expand on that last point, suppose you are writing what is basically a romantic girl-gets-boy novel, but you want to include a diatribe against hunting: you just cannot do this effectively by, say, allowing your heroine to be accidentally present at a hunt, and then moving on, after that scene and your diatribe, to the next part of the romantic story, never mentioning hunting again – it will be obvious that hunting has nothing to do with the rest of the book and that the scene has been stuck in for propaganda purposes; what you have to do instead is to involve your heroine in the scene in some way, so that it not only affects her, but has a major impact on the rest of the story – or perhaps you will need to set the whole book in hunting country and among hunting people so that the arguments for and against can provide a legitimate background to your main narrative. You can include anything you like in your book, provided that it is capable of being integrated fully into the story, and if you are determined enough and you delve sufficiently deeply into your imagination, you can always find a legitimate way of introducing any particular material you want. But it must *belong*. If it doesn't, leave it out, and don't let yourself be distracted by irrelevancies.

The Haphazard Nature of Plot-building

Before moving on to consider, as I shall in subsequent chapters, specific aspects of a plot, it is perhaps essential to make it clear that there is no simple formula to be followed in the way that you set about the plot's construction. I shall be looking at the various elements which make up a plot one at a time and in what may seem to be a logical sequence. In practice, however, it is usually impossible to consider the basic story, the characters, the sub-plots, the backgrounds and so on in any particular order and certainly not in isolation one from the other. Most novelists would confirm that the putting together of a plot is a process which is almost, if not entirely, incapable of being separated into various stages or compartments. Although one can usually pinpoint the moment when the whole thing begins (and I shall be dealing with this in the next chapter), the different elements of the story tend to arise out of each other, and affect and alter each other, and they often do so simultaneously and in a fragmented way, so that the novelist would be hard put to it to say which bit came first. As we shall see later in this book, the plot arises largely out of the characters and their actions and reactions. But the characters themselves can be affected and sometimes indeed formed by the background to the story, which itself may have a hand in shaping the plot. Similarly, the sub-plots often have considerable influence on the characters and the main plot, especially since they should not be isolated stories tacked on to the main narrative for no good purpose, but should be integrated into the main plot, arising out of it and affecting it.

Moreover, nothing of this is fixed and immutable. The author can manipulate the plot in any way he or she likes, and that makes the process even more complex and difficult to tackle in any kind of set sequence. It is rather like doing a jigsaw puzzle without a picture to guide you, so that only when you have done quite a lot of it do you begin to see how the parts all fit together and are then able to continue and eventually complete the design.

Don't be put off, however. It may all seem depressingly

complicated, but in fact that's all part of the fun – and, believe me, writing fiction is fun, and can provide you with an immense amount of pleasure. Mind you, producing a satisfactory novel is not easy, but few worthwhile things are, as I'm sure you will agree.

2 *The Starting Point*

The Rules of Writing
There are hardly any rules about writing – you can do it
where and how you like, you can write about anything
and in any style. But one rule to be observed if you want to
be successful is that you must have a professional attitude,
which means, among other things, that you understand
that writing is more than a hobby, more than a pastime – it
is a job of work. It is not something that you can do only
by waiting for inspiration to strike.

Most professional writers I know have little time for the
idea of waiting for inspiration. They will tell you that the
only way to write is, as an American author said, 'by
applying the seat of the pants to the seat of the chair.' And
having applied the seat of the pants to the seat of the
chair, a writer doesn't sit around waiting for inspiration; a
writer writes.

On the subject of inspiration, I have a great fondness for
a short, pithy sentence from the pen of the American poet
and humorous writer, Peter de Vries: 'I write only when I
am inspired,' he said, 'and I see to it that I'm inspired at
nine o'clock every morning.' That is a truly professional
attitude, and that is the way to approach your work. You
may not be able to sit down at nine o'clock every morning,
but whenever you can find the time to write, then you
don't wait for inspiration – you make sure that you *are*
inspired, at least to the extent that you just get on with the
job in hand.

As for finding the time, William Buchan tells a relevant
story against himself in his memoir of his father, the
popular novelist, John Buchan. 'I have often been rebuked

in my life,' he writes, 'especially when young, but never so gently yet effectively as by Walter de la Mare ... I had gone down to see him at Twickenham. After we had talked for a while about something he was doing, he enquired, "And now, what about you? Are you writing?" I suppose that I assumed a harassed expression, as of one bearing excessive burdens, and said that I had no longer any time. De la Mare reflected for a little, looked up at me with a detectable gleam of irony in his eye, and said: "I shall see if I can find you a piece of time ... I imagine it dark, and green, like glass ... to keep on your dressing-table." A nicer way of being told not to be an ass I have never heard.' We can always find the time if we want to badly enough.

You may ask, however, whether you really can produce worthwhile work by forcing yourself to write. Is it not better to wait until you are in the mood – until, in fact, you are inspired? But, believe me, if you sit around hoping for that magic thought to strike you, it may never come, and so you may never start at all. As for the quality of the work which is produced under the discipline of regular writing, I must be honest and admit that it varies. As a professional writer I sit at my desk every morning and in front of me is a blank word processor screen which has to be filled up with words; so I fill it up, whether I feel like it or not. Sometimes I do feel like it, and the words flow out in a constant stream and the three fingers I use for typing can barely keep up with the the thoughts in my brain. It is very exciting. On other days, I feel dull and lethargic and would much rather go and watch television or take the dog for a walk or go to sleep, but I force myself to write. And the results? When I look at the pages that I have produced on the 'good' day, I am often pleased, feeling that I have written something which is not at all bad, but equally frequently I will think 'what a load of rubbish!', and that day's work will end up in the waste-paper basket. Exactly the same is true of the 'bad' day, when it was a struggle to write anything at all – sometimes the work shows clearly what a struggle it was, and on other occasions I am delighted to find that it is better than anything I have done on a 'good' day.

The Flash of Inspiration
Of course, just as there are various interpretations that can
be put upon the word 'plot', so there is more than one way
of looking at inspiration. You can think of it as this magical
thing which comes to you out of the blue and when you
least expect it, so that everything falls into place and your
novel is suddenly there, complete and satisfying, needing
only to be set down on paper – the kind of experience that
poets are often believed to undergo before producing,
without need of any amendment, a whole new poem.
That's the kind of which I am so sceptical, because it very
rarely ever comes – most poets have an initial struggle to
express their thoughts and when they have got something
down on paper, they revise it over and over with as much
discipline as any other kind of writer, rarely relying on the
kind of 'inspiration' that we have been talking of.

On the other hand, all writers can and do regularly
experience a lesser form of inspiration – the kind which is
often called 'a *flash* of inspiration'. This is the sudden
brilliant idea which, although it doesn't hand you a
complete novel, may give an unexpected twist to your
plot, or solve a difficulty in its construction. It might be the
realization that a real-life event from the period of your
story can have a crucial effect on your characters, or it
could be a comparatively minor matter such as the striking
metaphor which comes into your head and gives colour
and excitement to a particular sentence in your story. That
sort of inspiration is worth having. But make no mistake
about it, you can't hang around waiting for it to strike. You
just have to keep on writing. That's the bad news. The
good news is that the more writing you do, the more often
this kind of inspiration will come to you. Apart from his
little joke, I think this is what, at least in part, Peter de
Vries was getting at – if you persevere and discipline
yourself to write, then you can truly 'see to it' that flashes
of inspiration come to you reasonably often.

Now, how does all this affect plotting? If it is no use
waiting for inspiration, where do you begin?

Where the Plot Starts

Almost all tutors of Creative Writing, talking of the origins of fiction in the author's mind, ask their students at some time or other, 'Where do you start – with Plot or with Characters?' And whatever the students may say, the tutor always pronounces a resounding vote for Characters. I have said the same thing myself, particularly in my book *Writing for Pleasure and Profit*. I must be honest, however, and confess that I have come to the conclusion since that book was written that I don't really believe it's true. Characters may come *before* Plot, but they're not necessarily where you start – they are not where fiction originates.

As an example of the way that Creative Tutors go on, let me quote from *From Pen to Paper*, Pamela Frankau's fascinating book about her writing life. She tells how, shortly after World War II, she was tutoring a class in Creative Writing in the Post-Hostilities School of Army Education. She asked her pupils to imagine that they had been commissioned to write a short story, and this is how she describes what followed:

'Now where are you going to begin? What do you look for first?'

'A plot,' they said in chorus.

'You wouldn't think about characters first?'

No, they wouldn't. Once they'd thought of a plot, they would think about the characters; not before.

'All right. We're going to make up a short story together. If I give you the plot will you provide the characters?'

They were agreeable.

'The plot,' I said, 'is a simple one. A murder story. The murderer invites his two victims to dine with him. He has chosen to kill them by the rather unorthodox method of screwing the dining-room ceiling down on top of them until they're squashed. This means some elaborate mechanical preparations and some tricky timing. At the last minute they are saved because the floor gives way, dropping them a comparatively small distance into the cellar, out of harm's reach.'

My class accepted the plot. 'Here we go, then. Now it's up to you. Who is this man, this murderer?'

Someone in the class suggested he was a Civil Servant.

I accepted the Civil Servant: 'But you must tell me all about him. Remember that when you create a character you want to know much more than you ever put on paper. He's got to be a real person in your mind: as solid as your neighbour at the next desk. What's his name? Any ideas?'

They came up with Augustus Simpkins. I wrote it on the board, with the rest of their findings.

He was a mousy little middle-aged man, with a mousy little middle-aged wife. Faithful to her? Yes. Crazy for her? No. Just putting up with her? Yes. He did his job adequately but no more. He was never late for the office. He didn't drive a car. Nor ride a motor-bicycle? Certainly not. He liked gardening. He took his seaside holiday at the same place every year. He was practically teetotal; a bad sailor; he paid his bills regularly. What did he read? They didn't know, though they assured me with some fervour that he never read novels. Poetry? No, indeed. On we went. At the end of a very few minutes every space on the blackboard was full and we had a satisfactorily complete portrait of Augustus. I called a halt.

'Now then, is that a well-drawn character? A believable person?'

'Yes,' in chorus.

'You really think Augustus could exist?'

Defensively now, they swore he could. Didn't I think so?

'Yes, I do indeed. I think you've done very well. He's alive.'

While they relaxed and smiled upon me, I summed up Augustus:– 'A nice, timid, unimaginative, unadventurous little fellow; fond of routine and peace; no particular discontent; no hobbies except his garden; no mechanical knowledge, no special skill ...' The temperature had begun to drop; they were getting it. 'And now,' I said, 'I must ask you:– is Augustus a murderer? A methodical murderer? Could Augustus devise and make a screw-down ceiling in order to commit this murder? And quite

apart from that point, who are his enemies? Where are his motives?'

At this point Miss Frankau's students apparently gave up, and admitted that they would have to begin with characters rather than plot.

It is an amusing account, told with considerable skill, and to a limited extent Miss Frankau proves her point that characters must come before plots. But it has to be said that her class must have been remarkably stupid if all through their creation of Augustus Simpkins they could forget that he was to be a murderer of outstanding ingenuity and ability.

It was also a bit unfair to ask the students about his enemies and his motives when Miss Frankau hadn't suggested earlier that they should even to begin to think about them – the kind of character that they had created *can* have enemies and *can* be surprisingly clever at devising means of getting rid of them.

But my main quarrel with the story is that the class weren't given a *plot* at all. Miss Frankau offered them no more than an initial idea. If a plot is the skeleton of a story, what we have here is just the backbone, and before we can really recognize it as a plot we need to add in the rib-cage and the pelvis and the tibia and the femur and all the rest of the bones, among which we would find Augustus Simpkins' enemies and his motives, an explanation of how he managed to construct his screw-down ceiling, and so on.

However, it is precisely out of the kind of idea that Miss Frankau gave her students that a plot could grow.

The Originating Spark

What I am saying is that most fiction begins neither with the creation of characters, nor with the construction of a plot, but with an idea. I like to call it *an originating spark*. An originating spark is usually extremely simple. Miss Frankau had slightly embroidered hers by adding in the fact that there were two prospective murder victims and by explaining not only that they escaped but how they did so, but it could have consisted only of the idea of a murder

committed by means of a screw-down ceiling, without any further details whatsoever.

Originating sparks come in many forms, and all sorts of things can start you off: it could be a scene – an Elizabethan house, for instance; or an overheard snatch of conversation – 'Of course, her sister was the talented one.'; or something that you happen to witness (or which is perhaps imaginary but which you can see in your mind's eye) – a girl slapping a man's face, and then running away; or a title – most Creative Writing tutors will agree that the imagination of their students is often greatly stimulated by being given a title (although that is perhaps more likely to work in the case of short stories than of novels); or a background – a war, an industry, an exploration. The originating spark doesn't have to relate to the beginning of the story – it doesn't have to provide the opening paragraph; it can come anywhere.

Your originating spark may be simple or more complex – like Miss Frankau's example, it might include other details, or combine a number of elements. But at this initial stage it is no more than an idea – it is not a plot, but simply the seed from which a plot can be grown. (I suppose, by the way, that the originating spark of a detective story may often consist of the method of murder – which is probably why Miss Frankau, a more than competent novelist, instinctively chose it as the most interesting part and the real starting point of her so-called 'plot'.)

It is a curious fact that the originating spark, the seed, which is so important in starting a novelist off, may occasionally be totally discarded as the plot of the novel develops. The background about which you wanted to write is replaced by something different which allows your story to go in a more interesting direction; the scene (the girl slapping the man's face, for instance) which you had visualized so clearly never becomes part of your novel. This does not, however, diminish the value of the spark as the initial stimulus.

The originating spark is far less likely to disappear when it is of a rather different nature – not just an incident or a visualized scene, but a much broader idea. Perhaps you

have a story you want to tell about a girl who falls in love with a man who has Aids, or about the first woman to become head of the Stock Exchange, or about the princess who marries the bootboy, or about the coward who becomes a hero, or even about a man who invents a screw-down ceiling in order to murder someone. In other words, your originating spark is a character whose story you want to tell. Are the Creative Writing tutors right in such cases to say that characters come first, before everything else? Not really, because the character which is an originating spark to the author is usually little more than an idea, rather than a fully formed person – it is still no more than a seed.

The True Beginning

A few paragraphs ago I said that most novels begin with an originating spark. But now I want to suggest an even earlier starting point – the desire to write a particular kind of novel. That's where it really begins – not with a plot, not with the characters, not even with the originating spark, but with the answer to the question of what you want to write about. Is your novel to be contemporary or historical? Is it to be a romance or an adventure story or science fiction or a western? A detective story, perhaps, or a thriller? A long family saga or little more than a novella in length, with two or three characters only? Is it intended to be light entertainment – 'a good read' – or do you have ambitions to write a Literary Novel, which might be a candidate for the Booker prize?

And what is the theme going to be? Are you going to tell a rags-to-riches story of fulfilled ambition, or a rags-to-riches Cinderella-type story of romance, or a story of revenge, or is the novel to provide a portrait of a disastrous (or perhaps highly successful) marriage? The possibilities are endless. *What is your novel going to be about?* Do not worry too much, by the way, about originality – at least not at this stage. Someone said that there are no more than seven basic plots, so the scope for originality is limited. Variations and twists on the standard themes, and freshness of approach are desirable, but they

come in later – in the way you treat your story, in the characters, in the background.

You may find, by the way, that a particular basic theme will run through all the fiction that you write – that your main characters are always motivated by jealousy, or a desire for revenge, or ambition. Again this is nothing to worry about – indeed, the fact that you keep returning to the same kind of story probably means that you feel strongly about it, and your writing will therefore continue to maintain the same interest and drive as your first work. Of course you should try to make the stories different from each other in detail – you should be writing 'variations on a theme', as it were. On the other hand, it has to be recognized that some successful writers go on writing almost exactly the same book over and over again for years and years.

As I said at the beginning of this chapter, there are hardly any rules about what you write or how you write it, and those which do exist may occasionally be broken with impunity if you know what you're about. Now, I have spent some time in this chapter in suggesting that the true starting point is the decision to write a certain kind of novel, and I would add that this decision is followed by the originating spark. Just to confuse everything, I have to admit that this is not a rule; occasionally the two elements can arrive virtually simultaneously, and it is also possible for the originating spark to come first and dictate the genre of book that you decide to write.

However, a more usual sequence is certainly deciding on the kind of story and then finding the originating spark, and the next stage is the creation of the characters. Let us see how it works in relation to the story of Miss Frankau and her students. The idea of writing a short story about a murder was the real starting point; the originating spark was the screw-down ceiling (plus the escape of the two victims); next would come the characters, which of course should have been tailored in the case of the murderer to fit the concept of a ruthless man with considerable mechanical ability; and finally the plot would have been constructed – the murderer's

motives (which would arise out of his character and those of the two victims), the background details, the way in which the story would unfold, perhaps some sub-plots involving subsidiary characters, and possibly something about the aftermath – does the murderer get caught, and how and by whom? In the course of working the plot out, it is quite possible that the originating spark would disappear altogether – you might find that you couldn't really make a screw-down ceiling sound even remotely possible, and you might decide to use a more conventional way of disposing of the victims; and the victims might shrink to one unfortunate man, who did not, alas, escape. Yet another alternative might be an extension of the story so that, the ceiling idea having failed, the murderer makes other attempts on the lives of his intended victims.

This is the way that plots can develop – you start with one idea, and perhaps end up with something very different. The reason why some beginners get bogged down in their attempts at novel-writing is often because they refuse to abandon or alter their original concepts, even if they prove to be unworkable. They cling to an idea, believing it to be startlingly new, which it probably isn't; and even if it is, what is the use if it is not really feasible? Never be afraid to change, to turn everything upside down, or even to throw it all away and start again.

Is Your Material Suitable for a Novel?
You can write a novel about anything you like – no subjects are barred nowadays – and you can use any approach to your story-telling that appeals to you. However, you might discover as you work on it that it isn't a novel at all – it's really a short story. In the same way if you were trying to write Miss Frankau's tale of murder, intended to be a short story, you might find that it is really a novel (which I suspect it is). How do you tell the difference between ideas suitable for a novel on the one hand or a short story on the other? If your material is complex, involving many characters and several sub-plots, and covers a longish time period, it is usually easy to see that it will be difficult to fit everything in within the

compass of a short story, even if you contemplate a length of over 10,000 words, which is unusually long nowadays for that genre. The problem seems more difficult in the opposite direction – in deciding in advance whether you have sufficient material for a novel. Hundreds of would-be writers begin novels and give up after the first couple of chapters; sometimes this is the result of a lack of stamina and determination, sometimes because, as already suggested, the author has been too inflexible over an unsuitable idea, but very often the problem is in fact that the material has simply run out – the plot was too thin, centred on a single incident, and perhaps concerned two or three people only – it was really a short story, and not a novel.

Another angle on this theme is to ask yourself whether you are in fact a novelist. Are you interested in the novel as an art form? Can you talk about the history of the novel, its development, and modern trends in fiction? No? Never mind – it's not essential. Could you at least write with some conviction about the function of the novel – to illuminate the human condition, to provide the reader with catharsis, above all perhaps to entertain? Even if you feel a bit shaky about producing an essay on those lines, it still doesn't mean that you are not a potential novelist. The one thing that you must be is a reader of novels who takes pleasure in them and, preferably, does so with some knowledge of what makes them pleasurable, whether it is the style, the strength of the characterizations, the imaginative quality of the story, or some other aspect, or a combination of some or all of these. I think you must also have the kind of mind which sees people and events not in isolation but as part of a larger pattern, and which is aware of the causality of which E.M. Forster wrote, as mentioned in the previous chapter – the fact that something happens for a reason and because something else has happened previously.

On the assumption that you have decided that you are not going to be entirely ruled out as a potential novelist, we can proceed. Once you have an idea of the kind of novel you want to write (and you are fairly sure that it *is*

going to be a novel, and not just a short story), you know what it's going to be about, and you also have the originating spark, you can go on to the construction of the plot. It is now that all those Creative Writing tutors are right, for what undoubtedly comes next is the characters, and it is they who will actually form the plot.

Don't Force the Pace
Before moving on to consider the characters – and that means not simply in this book, but before *you*, as you try to work out your plot, begin to decide who your characters are going to be and what sort of people they are – there is one piece of advice which is worth serious consideration. It is to take your time. Allow yourself time to think about the kind of book you intend to write, and to test your basic ideas, making sure that they are sustainable, and that they will provide sufficient material for the kind of novel you want to write. And allow yourself time for your subconscious to get to work. (Never, incidentally, underrate the ability of the subconscious to help in the creation of your novel – if you give it the chance and the time, it will beaver away and come up with the most useful material.)

The advice not to rush things is valid at all stages of your work (it's especially important when you come to revision) – never be afraid to delay actually putting words on paper or on the word processor's screen in order to think about what you are doing. The amount of time you will need at various points in the story may vary, but if you feel it advisable to stop and think, do so, and for as long as it takes.

I should make it clear, perhaps, that I am not referring to the times when you have to stop writing because something has gone wrong – perhaps an idea which sounded all right at the planning stage just refuses to work properly when you come to write it in full, or perhaps a character has come to life and started doing things that you hadn't planned. Those and similar causes will legitimately bring you to a halt and give you problems to think about. Nor do I mean the stop that you make when

you reach the point of deciding that what you are writing is dull and boring and that no one will ever want to read it (a feeling which all the novelists I have ever spoken to experience regularly) – in fact, you don't stop, but press on. Nor, finally, do I refer to the stoppage forced on you because you are suffering from writer's block, a disease for which, unless it is the result of some major problem in your life, such as bereavement, illness or serious marital upheaval, I have little sympathy, since it is mostly self-induced and can usually be cured simply by refusing to give into it, and getting on with your writing like a true professional.

What I am talking about is taking time out even when you feel you do not actually need to do so. Review what you have done so far, ask yourself if everything is still going along on the lines that you intended, think about what is to come in the novel, see if any new ideas come to you.

This advice may seem a little contradictory to my disparaging remarks at the beginning of this chapter about inspiration. But, as I hope I made clear, the concept of which I disapprove is that of *waiting* for inspiration to come to you, which I think is pretentious and unhelpful. I have nothing at all against the flash of inspiration which comes to a writer who is *at work*, and work includes thinking seriously about what you are writing or are going to write.

3 The Principal Character

Whose Story Are You Telling?
Once you have decided what sort of book you want to write, and have found your originating spark, you should next decide on your principal character. In many cases this will be easy, at least in the preliminary stages, because your chosen genre will dictate the sort of person your story will be about.

If you are going to write a romantic novel, for instance, you will be aware that your central character must be a woman in search of love (and probably marriage). If you are planning a fictional account of a real-life historical figure, he or she will clearly dominate the story. Or if you intend to write a highly autobiographical novel, then you will certainly know who the principal character is. In any of those cases, the main character is likely to be self-selecting.

(The autobiographical novel is not usually to be recommended for a beginner, by the way, for a number of reasons: the writer can rarely stand back sufficiently to produce a balanced effect; since he or she usually tries to be very faithful to real life, the story often lacks shape and drama; there may be libel problems, or at least the possibility of offending relatives and friends.)

On the other hand, suppose you are going to attempt a murder story, and have been inspired by the screw-down ceiling idea – is your central character the mad but brilliantly ingenious murderer, or one of the victims, or the detective who comes along to solve the crime?

You may be trying to work out a family story, and already have many members of your fictional family

buzzing around in your head, but which one are you going to focus on? Or, if you intend to write a saga, presenting several generations of the family, do you yet know whether one character is going to be the most important all the way through, beginning in youth and ending up as the indomitable matriarch who still rules the family (in family sagas nowadays it is almost always the womenfolk around whom everything revolves), or are you going to turn the spotlight on a different character in each generation (in which case you will perhaps be planning a book which is divided into parts, each of which is concerned with a different period in the family history)?

Again, you may want to write a historical novel about the Napoleonic wars, culminating in the Battle of Waterloo, but centred on fictional characters rather than on Wellington or Napoleon or any of the other real-life people involved in the campaigns. But are you going to give the starring part to a humble infantryman or cavalryman, or to an officer, or to the fiancée of one the soldiers, or to one of the easy-virtued camp-followers who attached themselves to any army in those days?

Yet again, you may have a polemical purpose in mind, wanting, for instance, to argue in your novel against the development of housing and factory estates in stretches of unspoiled countryside; if so are you going to present the arguments through an ordinary member of the public, or an expert, or an investigative journalist?

One Principal Character or Several?
At this point you may well ask whether it is essential to have a single principal character to whose importance there are no challengers. Is it permissible to write a novel in which there is more than one main character? Yes, of course, and many, many stories come into that category, especially those in which the primary concern is with the relationship between two human beings – a man and a woman, perhaps, or the hero or heroine on the one side and the 'villain' on the other. It has to be recognized, however, that one of the two is usually seen as the protagonist (a word which means precisely 'the chief character').

What about a novel with several main characters, none of which can be said to be more important than the others? Again, yes, of course. Family sagas often have a number of central characters, especially if more than one generation is concerned. The detective story may give almost equal prominence to the victim, to each of the suspects and to the detective (though the last named is fairly likely to be more important than the others).

Many authors have also successfully used a form which depends on a group of principal characters of near-equal standing – *Grand Hotel* by Vicki Baum, *The Bridge of San Luis Rey* by Thornton Wilder, and *Not a Penny More, Not a Penny Less* by Jeffrey Archer are just three examples of bestsellers in this style, and many others could be cited. Do note, however, that they all have an additional element, linking the characters together by something other than a close personal relationship or mere kinship, and this element is an essential part of the story. The links are of various kinds, but they could all be called extraneous. The characters are often strangers to each other, and have been brought together virtually by chance – they are all guests in the Grand Hotel (which, incidentally, becomes a kind of character itself), or they are passengers who happen to be travelling together on the same bus, or they discover that they share a common desire for financial revenge on the man who has swindled them all.

If this kind of novel, with a number of principal characters, is what you want to write, then go ahead. But you should be aware that it is not quite so simple to bring off successfully as it may seem. To begin with, it rarely works unless the essential link which brings the various characters together is both plausible and interesting. Even if you manage to find such a bonding element, you will still face other problems. Your novel will in fact be made up of a number of closely-related short stories, and considerable skill is needed in order to weld them into a novel, while maintaining the tension and avoiding a feeling of repetition. The stories must also be cleverly interwoven so that the characters are not isolated but become involved with each other.

The Point of View

Another major consideration is often referred to by teachers of Creative Writing as 'the focus of attention'. I think 'point of view' is a preferable term. It is a question of whether the story will be told in the first person, or in the third person through the eyes of the principal character, or in the third person through the eyes of the author. Here are brief examples:

First person: *'Will you write to me?' I asked. I could hear my voice trembling, and knew I was making a fool of myself. I gazed at him, but I couldn't tell from his expression whether he had even heard me, let alone how he would answer. Then John came over to us. 'Oh, there you are,' he said in his boring way. I knew my chance of getting an answer from Philip had gone.*

Third person, through the eyes of the principal character: *'Will you write to me?' Emma asked, her voice trembling. She knew that she was making a fool of herself. She gazed at him, but could not tell from his expression whether he had even heard her, let alone how he would answer. She looked up and saw John coming over to them.*

'Oh, there you are,' he said.

She thought what a bore he was, and knew, despairingly, that her chance of getting an answer from Philip had gone.

Third person, through the eyes of the author: *'Will you write to me?' Emma asked. Her voice was trembling, and she knew she was making a fool of herself. She gazed at Philip, but could not tell from his expression whether he had even heard her, let alone how he would answer.*

Philip was trying to keep his face as blank as possible, not wanting to encourage her. With luck, someone would interrupt them and he could pretend that he hadn't heard her question.

John saw that Emma had her intense look on, and decided that he had better rescue Philip. He went over to them. 'Oh, there you are,' he said.

'What a bore he is,' Emma thought despairingly, knowing that her chance of getting an answer from Philip had gone.

'What a bore he is,' Philip thought happily, grateful for his intervention.

The use of the first person has certain advantages – it usually makes it easy for the reader to sympathize with

the principal character and it gives a great sense of immediacy. It allows opportunities for the narrator to indulge in introspection, which can often be very revealing. On the other hand, it presents the author with the problem that nothing in the story can easily be included unless the narrator (the 'I' of the story) is present or is directly aware of whatever it may be. The practitioners of the first-person narrative say that it is always possible to get the necessary information across: to describe the appearance of the principal character, he or she can look in a mirror; information which the principal character needs to know can be given to him or her by another character, or in a letter, or can appear in a newspaper. However, the one thing that the first-person narrator can never do is to know exactly what is going on in the heads of the other characters, and sometimes it is very useful for the novelist to be able to show those different points of view.

It is worth stressing that use of the first person seldom works well when the narrator is not actively involved in the events he or she is describing. If he is simply an onlooker, the principal virtues of this approach disappear – there is no immediacy, and no reason for the reader to identify with the narrator. An interesting example occurs in *Wuthering Heights*, which in fact has two first-person narrators: Mr Lockwood, whose function is really confined to asking Mrs Dean, who is the principal narrator, about the relationships between the Earnshaws, the Lintons and the Heathcliffs. Mrs Dean's close involvement in the story arouses the reader's interest and belief in her; Mr Lockwood, on the other hand, is a somewhat shadowy and uninteresting figure, because he remains always on the fringe of the action.

A narrative in the third person is generally an easier method to adopt. If, however, you use your own eyes as the author to tell the story, it is much less easy to arouse sympathy for the characters, and the whole thing is likely to have a feeling of remoteness about it. This approach is sometimes known as 'the God's-eye view', when the author moves to the viewpoint of various of the characters

in turn, allowing the reader to understand what each of them is thinking and doing. It is sometimes useful, but can not only give the impression of a lack of focus, but may be confusing for readers, who don't know which character they are supposed to be most interested in (while it is often good technique to withhold information for a time and keep your readers guessing, one thing they don't like is an inability to recognize who is the main character). The God's-eye view also often means that there is a lack of suspense in the story because it is less easy to present a situation in which characters (and therefore readers) do not know what other characters are thinking or planning.

The God's-eye view can, however, be used very effectively in a novel which has a number of principal characters.

The third-person narrative seen through the eyes of the principal character is the most frequently used technique and it generally works very well, particularly if the novel revolves around one person whose importance outweighs that of any of the other characters. It avoids the restricted vision of the first-person story, but it has more focus than the God's-eye view, and it usually allows the reader to sympathize readily with the protagonist.

It is possible, of course, to use a combination of these points of view. So you could have a story told partly in the first person, and partly in the God's-eye view. One of the most successful techniques is the third-person narrative seen through the eyes of the principal character but with occasional short passages of God's-eye view, so that while the focus remains firmly on the most important person in the novel the author can, when necessary, take the reader briefly into the mind or describe the actions of one of the other characters, especially if he or she is of major importance in the story. However, these excursions into other people must be very fleeting, so that the focus on the main character is undisturbed; unless you are clearly using the God's-eye view throughout, readers find it disconcerting if the point of view suddenly switches.

Whichever point of view you use, it is something that you should decide on at an early stage, since it may affect

the choice of your protagonist, and his or her characteristics.

Reader Identification

As has already been said, in many cases you will know without any doubt or without even having to stop and think about it, whose story you want to tell. But if you are not as sure as that, how do you choose your hero or heroine?

The first certainty is that it will be someone who interests you – don't ever try to write a novel about a person who bores you, because you will undoubtedly end up boring your readers. And although novels *have* been written with a totally unsympathetic protagonist, it is almost as important that you should *like* the character as that you should be interested in him or her. If your hero or heroine has the right kind of qualities – is reasonably honest and truthful, believes in justice and freedom (and will fight for them if necessary), can face disaster with courage, and has a sense of humour – you have a good chance of achieving 'reader identification' for your character. This means that your readers, all being quite certain that they share exactly those virtues, will see the character as to some extent an extension of themselves, and will be emotionally involved with his or her problems and will want to see a successful outcome to them. The more you, the author, can identify with the character, the more readily your readers are likely to do so.

Of course, your central character does not have to be a total paragon, and indeed a few faults must be present if he or she is to be credible and human. It is comparatively easy to become so besotted by your hero or heroine that you make him or her into an impossibly nice or capable person, or both. Nobody is perfect, and fictional characters who even approach perfection are pretty unbearable, so don't forget to add some little weaknesses. We all tell lies (even if only of the 'white' variety), we all make mistakes, we all occasionally do things of which we are ashamed. But keep the failings in check. Although you might think that, since most people have as many vices as

virtues, it would be possible to persuade them to identify with a far from perfect character, it's a very difficult thing to bring off successfully.

The age of the protagonist is an important factor in reader identification. On the whole, readers find it easier to identify with a hero or heroine who is the same age or younger than they are, but less easy to accept an older character. That is a generalization, of course, and it is not difficult to find examples of successful novels with elderly central characters, and if you are writing the kind of story which stretches over a considerable time period, your readers are unlikely to have difficulty in identifying with your protagonist even if he or she ends up much older than they are. Nevertheless, good stories are sometimes turned down by publishers because they feel the central characters are too old.

Where Do Characters Come From?

In order to create a central character with whom your readers will sympathize, you might consider basing him or her on yourself, because (as you will no doubt be willing to admit without too much arm-twisting) you have the right sort of virtues, with an interesting little sprinkling of extremely minor vices, and you will certainly be able to identify with yourself when you put yourself on the page.

You may consider that to be a ridiculous idea. You have no intention of putting yourself into your story, which is to be about people totally different from you. 'Surely,' you may say, 'writers, and especially novelists, are observers. Writers watch and listen, and when the time has come to create characters and describe events, they draw upon the store of knowledge which their observation has built up.'

There is a lot of truth in that. Writers certainly *are* observers, and would probably not produce worthwhile novels if they were not able to stand back and note dispassionately what is going on around them. They also need to be endlessly curious about the people they meet, including the complete strangers they pass in the street or sit opposite in a train, as well as their families and friends.

They probably have a smattering of psychological knowledge, too – at least they try to understand the human beings they study.

Writers are also readers (indeed, they *must* be readers), and there are two particular rewards to be gained from reading, especially if the books are in the same genre as the one in which you hope to be successful: firstly, one of the best and most enjoyable ways of improving your own writing is by analysing and learning from the techniques that published writers use; secondly, each time you read a novel you will add to your store of knowledge about human beings, and this will be of considerable help to you when you come to create characters.

Incidentally, it is worth pointing out, while we are considering characters based on observation, that successful writers of fiction very rarely take their characters direct from life. They do not do so partly because of the possible embarrassment, or even the risk of libel, which may result, but the main reason is because, as I have already said, true novelists are not photographers, but artists; they do not record life or people or events exactly as they are, but manipulate and edit and embroider so that the final picture shows what they want it to show, and nothing else. A faithful portrayal of someone you know is liable to distort your work of fiction because it is unlikely to fit perfectly into the story you want to tell. Therefore, when successful authors take characters from life they usually make an amalgam – bits from this person and bits from that, and an odd characteristic or physical feature from a third and a fourth, and so on, so that the resultant person might legitimately be called an original, newly created.

Having said all that, however, I want to revert to the paragraph in which I suggested that the writer might draw upon himself or herself for the creation of the principal character. Although observation of others is an important factor, I believe that the main source of characters is always the writer, because we all have a vast store of different people within us. Think of yourself in a variety of different circumstances and realize how many different people you can be – you being polite to a fellow

guest at a party, you being kind (or beastly) to a relative, you being irritable and selfish when stuck in a traffic jam, you being brave in the dark, you being terrified by a spider, you being obsequious to your boss, you being wise and just to your children, you being ... I could go on and on and on, but I am sure you get the idea. We really are a whole lot of different people. And those are simply faces that we present to the world – while we are behaving politely, kindly, irritably, selfishly and so on to other people, we are simultaneously aware that these are just façades, and that something different lies beneath them.

But that is not all. Each one of us is unique, true, but only in so far as we possess the components of which we are made in slightly different quantities and combinations. Consider human beings first from the physical point of view: we are all different in detail – we don't all have blue eyes, we don't all have black skin, we aren't all six feet tall – but at the same time we are all basically the same – our bodies and the processes by which we keep them functioning are all alike. When you think of the mental abilities of human beings you may feel that the differences are greater – some of us are brilliant, others fairly bright, and you can continue the progression downwards until you come to 'thick as two planks', bearing in mind too that the brilliant mathematician may be thick as two planks when it comes to working out a cryptic clue in a crossword puzzle. But these contrasts in mental capacity are still little more than variations on a single theme, and sometimes more the result of social background and upbringing than of the presence or absence of a built-in talent. When we look at the emotions, which are perhaps the most important aspect of the human entity for the novelist's purposes, again we find that we all have different temperaments – in medieval times we were divided into four categories: sanguine, choleric, phlegmatic or melancholic, according to the humour which dominated in us the other three – but we find too that these are only differences of degree; all human beings experience the same kind of feelings – love and hate and fear and happiness and misery and anger and envy, and so on –

and we all share the basic instincts for self-preservation and the propagation of our species (which lies behind the great driving force of sexual desire).

If you accept my proposition that we share with each other more than that which separates us, then you must agree that we have within us the seeds of all humanity. Some of the material may be very deeply buried, but it is there, somewhere in the subconscious mind. No doubt that material includes some of our experiences as conscious observers, but I suspect that we are born with (or at least absorb unknowingly in early childhood) most of the contents of the subconscious. You'd be surprised what can be found there. E.M. Forster wrote of writers putting down buckets into their subconscious, 'and when they bring them up they're as puzzled by them as anyone else'. Let us suppose for a moment that you are a nice, well-brought-up, softly feminine lady, gentle, kind, tolerant, quick to forgive, etc., etc. Would it surprise you to learn that down there in your subconscious is a guttersnipe – selfish, cruel, bigoted, vengeful, and with a chunk of masculinity thrown in? But, believe me, it is all a part of you, and if you put buckets down into your subconscious you will find that Forster is right and that all sorts of extraordinary things can be brought to the surface. Writers need to train themselves to use the subconscious in this way. The subconscious is rather like a library – you've got to learn how to find the books in it that you want and accustom yourself to borrowing them.

In his book, *Approaches to Writing*, the American writer Paul Horgan said, 'I am everyone in my novel. If this were not so, no one in my novel would have a chance to ring true, even as I work to make each character an individual, different from the rest.' In the same way, in all my own novels all the characters are built from facets of me – of me as I am (at least in part), of me as I should like to be, of the nasty, vicious me, of me in all kinds of disguises – including, of course, me in the person of a woman. No doubt you know the theory that we keep our souls shrouded in seven veils; for friends we will strip away one, two or three of the veils; for lifetime partners, we will

drop the fourth and fifth, and possibly, though rarely, even the sixth; but we never ever let anyone see what lies behind the seventh veil. It may sound a fanciful concept, but it's probably true – except for novelists. Novelists have the facility to drop their own veils numbers one to six with the greatest of ease through the medium of the characters they create – they do so regularly, and may occasionally even lift the tip of the seventh.

Yet another factor is the ability which many writers share with actors of being able to project themselves into another persona. You probably know the splendid James Thurber story, *The Secret Life of Walter Mitty*, in which Mitty, a meek nonentity, daydreams of playing a heroic role in a number of different scenes. The story is popular with all those who read it, because they recognize themselves in Walter Mitty, but is of particular interest to writers of fiction, because the creation of characters involves a Mitty-like imagination.

Finding Out About the Principal Character
Even if the main character is simply another facet of yourself, he or she will not spring out of your head, like Minerva from Jove, fully grown and already equipped for the battles ahead. You will need to use your imagination, to add bits of observation, gradually building the picture up from comparatively little until the complete character is there in vibrant, three-dimensional reality – more like a living sculpture than a picture, perhaps.

One of the things which you should aim for is a considerable degree of complexity. You can choose to write about a simple, straightforward person like Augustus Simpkins (see the excerpt from Pamela Frankau's book, *From Pen to Paper*, in Chapter 2), who is weak, dull, unadventurous, predictable, or you could create someone strong and ruthless, but equally predictable. Of course, such characters do have the potential for jumping off their accustomed tracks, and acting in a quite unexpected way. Beneath Augustus Simpkins' mild exterior, even if one might not find the inventor of a screw-down ceiling, could be concealed a devilishly clever

murderer, and the strong and ruthless character might be a softie in the hands (or should one say 'paws'?) of a sex-kitten. But most human beings are complex – they have more than one ambition, they can be both kind and cruel, honest and two-faced, and while some parts of their lives may be ruled by routine, in other aspects there may be adventure and excitement. In other words, they are not wholly predictable, and if your main character has that same kind of complexity, it will probably be easier to devise a more interesting plot than that which will emerge from a simpler person.

Naming the Character

One of the first things you will want to do is to find a name for your central character. You may have noticed that when Pamela Frankau quizzed her students about the murderer in her story, the first question she quite rightly asked was what his name was – once a person is named we find it much easier to begin to visualize him or her. Her students chose 'Augustus Simpkins', a name suggestive of the meek and mild character which they subsequently drew. Of course, they were working almost fifty years ago, when characters in popular fiction were often given names which acted as a kind of shorthand definition of the sort of people they were. Some names had certain characteristics very firmly attached to them – Jasper was inevitably a villain, while Percy, for instance, had an aura of foolishness (so it was the perfect name for Baroness Orczy to choose for her hero – who could imagine that Sir Percy Blakeney was the Scarlet Pimpernel?).

This device, in its cruder manifestations, is largely out of fashion nowadays, but names in fiction do still give some suggestion of character to the reader – Augustus Simpkins may turn out to be another Rambo, but our first impression when we come across the name will probably be that he is a milk-and-water person. Moreover, names give certain other signals – they often tell us, in our supposedly classless society, something of the person's social background (think of names like Wayne and Darren on the one hand, and Dominic and Julian on the other),

and they can certainly give the reader a strong hint as to the period (if a story features two young women called Florence and Edith, there is a good chance that it takes place around the time of World War I, whereas Joan and Dorothy would suggest a setting some twenty years later).

It is worth taking considerable trouble over the selection of names for your characters, and I would recommend consultation of *The Guinness Book of Names* by Leslie Dunkling. Most important of all is to find the right name for your central character – a name that is suitable for the period, that is reasonably euphonious and easy to say (remember that your book may be read aloud, and even silent readers 'hear' what they are reading), and, above all, a name which seems to you to be right for the character which is beginning to emerge in your mind.

The Importance of Knowing Everything About Your Central Character

Many tutors recommend that you should make out a sort of dossier for your most important character, in which you will set down everything that you can think of about him or her – age, physical appearance (looks, colouring, height, weight, build), occupation, hobbies, background (parentage, social class, upbringing, education), beliefs, characteristics (strengths, weaknesses, intelligence, likes and dislikes), relationships (family, friends, business colleagues), sexual proclivities, ambitions – and you can extend the list as far as you like. The point of all this is to get to know the character through and through, backwards and forwards, so that he or she becomes absolutely real to you. Then you can put that character into any situation and will know exactly how he or she will behave; and we shall see in a moment just how useful this can be.

Although I recommend this approach myself, I have to confess that when writing a novel I do not use it. Instead, I simply live with my characters over a long period of time, so that I get to know them in exactly the same sort of detail, but without writing it all down. In the process, they become close friends, and very much alive to me. It really

doesn't matter whether you write down the details, or follow my method, or use a combination of both systems – the important thing is to get to know your characters as well as you possibly can, because it is the only way that you will make them come alive on the printed page.

Don't, by the way, skip any part of your character's personality or history on the grounds that you won't be dealing with it in your novel. You still need to know about it. Any novelist telling any story always knows far more about the characters and the background and a whole host of other things than is actually used in the story itself. So don't neglect your character's childhood, for instance, even though you will be writing about him or her as an adult and without any flashback to earlier years. Remember what a major influence on all of us our childhood is.

Your Character's Ambitions
Although parentage, social class, upbringing and education are among the most important factors in that list given a few paragraphs back, I would say that the most significant item on it, particularly from the point of view of plotting your novel, is the last one – the character's ambitions. This is in fact the basis of plotting: find a character, put him or her in a certain situation and give him or her an ambition, a goal to aim for. The ambition may be to invent a screw-down ceiling with which to dispose of a couple of enemies, it may be to drag Mr Right to the altar, it may be to frustrate the knavish tricks of our country's foes, it may be to become rich or powerful or to gain revenge, or, and this can often be just as dramatic as attempts to reach a definite objective, it may be simply to escape from a situation in which your hero or heroine is less than happy, without necessarily looking for any ambition beyond the escape. And do note that the character will more often than not have more than one ambition – to gain power and status, and also to establish a satisfactory relationship with that stunning blonde, or to escape from the kitchen and to see the Ugly Sisters get their come-uppance, as well as marrying Prince Charming.

The novelist and tutor of Creative Writing, Dianne Doubtfire, puts it a slightly different way when she suggests in her book, *Creative Writing*, that you should ask yourself what your main character's problem is. And note that she uses the word 'problem' because of the conflict, the drama, the suspense, the sheer readability that it suggests. If a reader is engrossed, she says, it is because the author has presented the character with a problem. The problem has to be solved, of course, so we could say that finding the solution is itself an ambition.

Whether we talk of ambitions or of problems, and whatever they may be, they are what the story is all about. Another definition of 'plot' is 'a sequence of connected events which begin with and stem from the main character's ambition or problem'. Do note that phrase 'a sequence of connected events'. The ambitions of the central character can be almost anything at all that a human being could want to achieve, but if you allow your hero or heroine to get to his or her goals without difficulty, you won't have much of a novel. It won't have any conflict or excitement, or indeed any real story. When you have discovered who your central character is and what his or her ambitions are, you have to put barriers in the way of their achievement, and it is these which bring about the sequence of events.

The barriers can be of many different kinds – physical (how can your heroine hope to ensnare Mr Right now that he has gone to live in Australia?), or practical (how exactly *do* you make a screw-down ceiling? or, how is our intrepid agent hero going to get into the secret place where the plans are kept, and get out again?), but they are at their most dramatic, and therefore most useful to your plot, when they are concerned with other people (it would all be plain sailing for your heroine if it weren't for the Other Woman; or, there's no way your hero is going to become rich and powerful while the present boss is determined that his rotten son shall be his successor; or, your character may be able to take revenge, but only at the cost of ruin for his or her best friend). The relationship barriers can also include the intriguing problems caused by

misunderstandings or by the principal character's own traits (pride, lack of tact, stubbornness, or whatever). Barriers provide conflict between the protagonist and his or her ambitions, and often between the protagonist and other characters in the story. Conflict is essential to the novel.

Yet another aspect which you may have to consider, especially if your story extends over a considerable time period, is that your main character's ambitions or problems may change. The man who dreams of revenge may discover in later life that other things are more important; the young woman whose sole ambition was to marry Mr Right may find that a business career has more interest for her than domesticity.

It is at this point in the process of plotting that the depth of characterization which you have given to your central figure will begin to pay dividends. Face him or her with a barrier and see what the reaction is. If the character is strong, he or she will probably find some way out of the difficulty. Characters actually seem to do this all by themselves, without the author's help, as it were. If they can't do so, then the author may have to lend some assistance. How? By asking, 'How can I make this happen?' and then throwing up ideas – 'What if he should do such and such? What if she should tell a lie/tell the truth/refuse to answer? What if they should both ...?' – and you go on asking 'What if ...?' until you find a satisfactory answer to the problem.

You must make sure, of course, that all the possible solutions to the problems facing your central character are considered in the light of the kind of person that he or she is, so that the answer which you find does not make him or her act out of character (test the credibility by asking yourself, 'Would he really do that?', 'Would she really say that?'). This, incidentally, is a very important point. You must never ever allow any of your characters to be manipulated by the events in the story into becoming something that they are not, or doing or saying something which they would not do or say. You may argue that in real life people are always acting in the most surprising,

out-of-character way. Yes, of course. Human beings are pretty complex, and even the most dependable will occasionally do something totally surprising of which we would never have suspected them to be emotionally capable. But since fiction is a controlled and to some extent unreal reflection of life, characters should not behave irrationally – at least, not without some hint being dropped by the author to suggest that the character has a certain element in his or her make-up which will allow of such behaviour. Augustus Simpkins *could* be a murderer, but it would be necessary to give the reader an inkling, early in the story, that he has a ruthless streak; then, when he turns out to be a vicious criminal, his villainy will be seen as out of character only to the other people in the story, and not to the reader. What would be much more difficult would be to turn him into the inventor and builder of a screw-down ceiling – and that is a good example of the principle that characters must always dominate plots, so that they are not themselves distorted by the exigencies of the story.

It is quite likely that your protagonist's response to the first crisis in your story will lead inevitably into a second problem for him or her. Very often the new difficulty arises because his or her attempt to overcome that barrier only makes things worse, often involving other people. To quote Dianne Doubtfire again (but this time from *The Craft of Novel-Writing*): 'People, as we know only too well, are inclined to create difficulties for themselves and others.' And that is how your plot begins to build up. Plot arises out of your characters and their reaction to the crises which they, or others in the story, face, and particularly out of their reactions to each other.

One other important point to remember is that your principal character should develop and be changed by the events of your novel. We do not go through life unchanged – we are affected by the things that happen to us and to others, and of course we alter with age. All experience is educative to a degree, but we often learn more from the difficulties which we encounter, and every barrier which your main character overcomes should

change him or her in some way, however subtly. Build the potential for development into the characterization from the start.

The Vital Importance of the Central Character

The creation of the principal character is undoubtedly the most important part of plotting the novel, and you should be prepared to spend a considerable amount of time on the job of making him or her as alive and as deeply understood by yourself as you possibly can. If you know from the first, or come to realize as the story grows in your mind, that you have more than one principal character, then you will have to work on both, or all, of them in the same way. There are sometimes advantages in having more than one principal character – since the plot and its developments arise directly out of the characters, to have two protagonists should give you double the opportunities for enlarging your story. Do, however, make sure that both, or all, of these people really are principal characters. Is your story really that of more than one person? Will the story be told from more than one character's point of view – or, more importantly perhaps, *should* it be told from more than one character's viewpoint? Unless you are sure that the characters under consideration are of equal importance, then the lesser ones will be the 'subsidiary' or 'secondary' characters which will be discussed in the next chapter.

4 Secondary Characters

Friends, Relations and Others

In a paragraph from one of his *Meditations*, which is partly about death, but mainly about the fact that we are all members of the human race, John Donne wrote those famous words, 'No man is an Island, entire of it self; every man is a piece of the Continent.'

We are not totally individual – as Donne said, we are part of everybody else, and they are part of us. That is true not only of our family, friends and acquaintances, but also of people whose names we know but whom we never meet, or, indeed, people of whom we are totally unaware. Our lives are altered by politicians, for example, or by the owners of the firm for which we work; equally, the life of a man unknown to us could be sent off in a new direction by so simple a cause as, for instance, whether we drove straight past him as he waited at a pedestrian crossing, making him miss his bus, or stopped to let him get across soon enough to catch it and to get to the station in time to scramble on to a train which, let us say, subsequently crashes.

If we are all part of the Continent in real life, it is equally so in fiction. It is quite impossible to write a novel with one character only – even if you somehow contrived a story in which no more than one person actually appeared, you would not be able to exclude the others from being there in essence, as it were (and it would be extremely dull if you did).

So as well as your main character, you will need others in your story. The range of their importance is immensely wide – some will be almost as prominent as the hero or

heroine, while others will be no more than supernumeraries. I am referring to them all as 'secondary', simply meaning that they are of less importance than the protagonist.

So who are these people? They are all connected with your hero or heroine; they are family, friends, acquaintances, colleagues at work, and so on, depending of course on the demands of the story. They are also casual contacts, such as someone serving in a shop, a taxi-driver, or a policeman – anyone in fact who plays some kind of part in the story.

It is impossible to say where you should begin in the creation of subsidiary characters, because the process will vary so much according to the kind of novel you want to write. If you are planning a romantic novel, you will by now know who your heroine is, and the next task will probably be to characterize the hero, and then perhaps the Other Woman, if there is one in the story; if you have a family saga in mind, you have to decide who the other members of the family are and which of them are going to play the major supporting roles; if you are writing a James Bond-style thriller, the most prominent secondary character might be the hero's chief opponent; if it's Miss Frankau's detective story, and your main character is indeed the fiendish and ingenious murderer, Augustus Simpkins, then you may now be concentrating on the two victims or on whoever it is who finally brings Augustus to book.

It is an interesting fact, by the way, that in a great many stories the main driving force comes not from the principal character, but from one of those who are merely secondary – one of the finest examples (if you will forgive a reference to a play rather than a novel) is to be found in the shape of Lady Macbeth. Such a person may be extremely important in your story, and will therefore need as much attention as you have already given to the main character.

Building Up the Secondary Characters
By the time you have got this far, you will probably have a fairly good outline idea of who the most important

secondary characters will be, but you may not know a great deal about them.

Where do they come from? Again, out of yourself and your subconscious, plus a certain amount of observation. However, another factor now enters the picture and this is the character that you have already built up for your hero or heroine. If the next most important character is, for instance, the man whom your heroine is eventually going to marry, then he has got to be the sort of fellow that she would fall for; if the most important secondary characters in your family saga are the mother and father of the strong, intelligent, fearless heroine, then they are unlikely to be convincingly portrayed as stupid nonentities (at least one of them – probably the mother – should share some of the characteristics of the daughter); if you are creating the evil head of some foreign power's intelligence agency, then he or she has to contrast with your hero, while being almost as clever and resourceful as he is; if you are looking at Augustus Simpkins' victims, clearly they must have backgrounds which have formed them into people that he wants to get rid of.

What sort of people are these secondary characters? Again, you can make out the kind of list described in Chapter 3, so as to set down all the details about each character's appearance, background, interests, etc., or you can simply get to know them in your mind, without actually putting the information down in list form. It is very important, however, to know as much about them as you can – probably to the same extent as for the principal character.

Again, it is vital to work out the aims and ambitions of the secondary characters, and especially how these will affect those of the principal character. Look for a moment at a standard romantic novel: the heroine's main goal is to get the hero to the altar; if the hero's intention is to remain unmarried (perhaps for what all right-minded people will think a good reason, such as not being able to afford to support a wife and family, or perhaps for what all wrong-minded people will think a good reason, such as being free to continue to play the field), this is going to

affect the heroine. It is going to provide a barrier which she has to surmount. This is a typical example of how plot arises out of character – the characterizations of these two people lead to conflict and drama and it makes a story. What happens next? How does the heroine get over that barrier? And supposing that when she has climbed it, the hero's intention has changed, but not in a way that suits her – what then?

When you have built up the characterizations of the main members of the supporting cast in your novel, you go on to do the same thing for the smaller parts, though the less importance in the story they have, the less detail you will probably need to go into, so that by the time you come down to the taxi-driver, for instance, you may not need to know anything more about the character than that he is a male taxi-driver. There is no question of laziness, inci- dentally, in not characterizing him in any more depth, provided that all he has to do is to drive one of the more important characters to wherever it may be; if you start to give him a background, and think of him as a real person, he will probably insist on playing a larger part in the story than you intended. This may be a good thing – it is what writers mean when they talk about characters coming to life and taking over (a subject to which I shall return later in this book) – but it does depend on whether the larger part he insists on playing adds in a worthwhile way to the story you are telling.

You may not yet be aware of the existence of some of the less important characters, and even major ones may be so shadowy in your mind as to make it impossible for you to go into them in great depth at this stage. They will emerge or become clearer as your plot progresses, and when they do, whichever point you have reached, you can think about them, find out exactly who they are and what they are like, and turn them into living characters, watching to see what effect they will have on your other people.

How Many Subsidiary Characters?

You can of course have as many characters in your novel as you like. If you are writing a long family saga or any

kind of novel which stretches over a considerable period, you may have a cast of hundreds. However, whether or not they will have some effect on the main characters is an important criterion when it comes to deciding whether the minor figures belong in the novel at all, and if so in what capacity. I have already said that all the secondary characters should be connected in some way with your hero or heroine. More than that, no character should be included in the story unless he or she is going to have a part to play which affects the main character in some way (indeed, nothing at all should go into your novel unless it demands to be there as an essential part of the story). With minor characters the effect on the protagonist may be very small and even remote and indirect (it may affect one of the more important secondary characters, for instance, who in turn and as a result does something which affects the hero or heroine), or it can be of the utmost significance – but the effect *must* be there.

I find sometimes, however, that it is possible to approach this problem the other way round, as it were. Supposing I feel that my hero should have a number of brothers and sisters, but I can perhaps see at first a significant role in the story for one of the siblings only; before eliminating the others (or, if they must exist, sending them to South America, or making them die young, or in some other way removing them from the story), I sometimes ask myself what this brother or that sister could logically do which would affect the main character and add to the interest of the narrative. On occasion this has resulted in a useful development of the story. However, if I can find no such use for these extraneous characters, they must be ruthlessly omitted or allowed to exist only on the outermost fringes of the novel.

It seems to me that it is always satisfactory when a subsidiary character can play a part, even if it is a minor one, throughout a novel. Look, for instance, at *Nicholas Nickleby* – Mr Squeers disappears quite early on, and seems to be forgotten, but (to the pleasure of the reader) returns much later to add other complications to the tale. I would like to suggest that when creating your subsidiary

characters you should ask yourself not only what part in the story they are to play, but whether they can be used in more than one way, without either acting out of character or making the plot seem too contrived.

Making the Secondary Characters Real
It may be comparatively easy to ensure that your principal character and the main secondary characters are real human beings, with a few faults mixed in alongside their good qualities – you can remember to allow them the occasional lie, or a momentary selfishness, or you let them say something they don't mean (and that, with all the resultant confusions, is a splendid device for complicating your plot). It is not always so simple with some of the minor characters, simply because you do not have the same amount of space to devote to them. It is, however, important to avoid allowing them to become caricatures, which can happen quite easily, especially when you think of the character only in terms of an unpleasant dominant trait. Even a vain, silly woman can have a little sense once in a while; even a cruel Victorian father usually believed he was doing his best for his children. Try always to see even your minor figures as rounded, three-dimensional people.

As I have already said, the central character of your novel will be a person with whom you can sympathize. This is not necessarily so when it comes to the secondary characters (and I am not referring here to a villain, or antagonist – I shall come to that important person later). For instance, you may be fairly extreme in your politics, whether on the right or the left, but may need to present in your novel an important secondary character of the opposite political persuasion to your own. You do not have to portray such a person in favourable colours and you can indeed use the character to demonstrate the correctness of your own views as opposed to those which he or she holds. What is essential, however, is that you should *understand* the person and the reasons why he or she takes that particular political view. You need to remove your own prejudices and to empathize with such

characters, whether it's a matter of politics or religion or any other controversial subject. A good novelist usually has many strong opinions on a variety of issues, but is also able to be a dispassionate observer, and therefore to present both sides of an argument with a reasonable degree of fairness, even if in the end he or she comes down fairly heavily on one side.

Similarly, although this may be easier to achieve, if you are presenting a character whose way of life is unfamiliar to you, it is vital to find out more about it. As a human being, you may share the same basic emotions as a police officer or a teacher or an actor, but unless you find out something about why such people chose the work they do, what the work consists of, their attitude towards it, and the way in which such factors have moulded their reactions to other people – in short, unless you *understand* them – you will have problems in bringing them satisfactorily to life.

Stereotypes
Because you do not spend so much time and thought on secondary characters, especially those of minor importance, it is quite easy to fall into the trap of using stereotypes – the harsh Victorian father, the comic charwoman (given to malapropisms, naturally), the prostitute with a heart of gold.

I think it is fair to say that forty or fifty years ago standards in popular fiction were much lower than they are today. It was an age when heroes and heroines came from the upper middle class or the aristocracy, when lower class people were either funny or brutal, when villains were sinister Chinamen or oily Levantines. If you have read many light novels from that era you may find yourself accidentally, as it were, using the same approach for some of your less important characters.

One reason for doing so may be an instinctive realization on your part that you need to have considerable contrast in your characters. Stereotypes are usually quite strongly characterized – indeed, they can be fully rounded and very much alive – but because they are

so immediately recognizable they are bound to make your novel seem unoriginal and tired. Avoid them if you possibly can.

The Value of a Confidant

A supporting character which you may find extremely useful is a friend, or sometimes a brother or a sister, in whom your hero or heroine can confide, thus telling the reader what is going on in his or her mind. The device does not work well, however, unless the confidant has a real part to play in the story, and affects its development and outcome in some way. This person therefore needs not simply to be a listener, but at the very least to give advice (not necessarily good advice) and encouragement perhaps, or to pass on information which would not otherwise be readily available to the main character. If he or she is actually a major player in the drama, that is better still.

A device which some writers have used is to make the confidant the narrator of the story. It can be effective, but, as has already been suggested, only when the narrator is deeply involved in the story. A narrator who is merely a spectator is always unsatisfactory.

The Antagonist

One of the most important characters in any story is likely to be the antagonist – that is to say, the protagonist's opponent or adversary. I prefer this term to 'villain', which may be appropriate in cases where the story verges on the melodramatic – especially perhaps in the spy thriller – but which in other circumstances may be too strong a term, conjuring up the wrong image for the hero or heroine's adversary, however much trouble that person may cause to him or her.

There may of course be more than one antagonist. Whether you have one or more, such characters are valuable as a contrast to the hero or heroine and as arousers of sympathy for him or her, and the part that they play in the story can be of crucial importance to the development of the plot. Very often, it is because of an

antagonist's actions that the protagonist is frustrated, at least temporarily, from achieving his or her aims and ambitions. Heroes and heroines often suffer from injustice – indeed, it is a good basic element for a plot – and the injustice has usually been perpetrated by an enemy.

Whether the antagonist is considerably less than villainous, or is an out-and-out evil-doer, great attention needs to be paid to the characterization. If you are writing a fairly crude story in which exciting physical action is of more importance than anything else, you may not bother with anything more subtle than an antagonist who is Evil incarnate, a grotesque creation without any depth except in blackness of soul. Even in that kind of novel, and certainly in any other sort, it is much preferable that the antagonist should be recognisably human, and the more fully explored the character is, the better. Find out just what makes the antagonist tick, what formed his or her personality, what are the driving forces behind his or her actions. You don't need to put all that you discover about the person into your story, but if you *understand* the character then your understanding is likely to rub off, as it were, into your writing, and the result will be a real human being rather than a pasteboard stereotype.

Just as the most saintlike of us has a few imperfections, so even the most horrible of persons has some small measure of good qualities. Although the writer hopes that readers will identify with the main character, and wish for his or her triumph, it is not at all a bad thing for readers to have a modicum of understanding of or sympathy for the antagonist. One of the things you can do to achieve this end is to give him or her someone or something to love – we always respond favourably to someone whose heart carries a portion of love, however tiny, and despite the fact that the rest of it is filled with hatred and cruelty and every other evil that you can think of.

Names

At quite an early stage, you will probably want to find names for at least the more important of your secondary characters. The same principles as those described in

Chapter 3 apply, chief among them being your own feeling that the names are right for the characters in question. However, there is an additional matter to be considered. It seems to me to be essential to avoid, as far as you possibly can, any confusion between your various characters – each should be an individual, distinguishable by differing characteristics. But it is not only their traits which separate one from another in a reader's mind, but their names. When I am writing fiction I make myself three lists of the alphabet; one is for the first names of male characters, one for the first names of female characters, and the third for surnames. As I come to each character, starting with my protagonist, I write the first name and surname on the appropriate list, the object being to avoid, as far as possible, names beginning with the same initial. If you are writing a long book, with a great many characters, it is impossible to do this, but at least you can see that duplications of the initial do not occur among the more important characters. I also make sure that at least some of the names vary in the number of syllables they contain – Jane, Mary, Elizabeth, for instance, or White, Henning, Scrivener – and I carry this obsession of mine to the length of trying also to avoid similar sounds in names – so I would not use, for example, both Renton and Hinton as surnames in the same story. The object of all this is to avoid confusion in the reader's mind.

Don't give a name to any character in your novel who is merely a supernumerary. You may need the taxi-driver in your story, but if his sole function is to drive someone somewhere, then don't name him; even if he is a little more important than that and says or does something which changes the principal character's life in some way, he should still not be named. Suppose, for instance, that he drives the hero to a club and says, 'The guv'nor's a mate o' mine. Good bloke. Name of Butler,' that may give the hero some essential information which he did not have before; or suppose the heroine, not knowing where to stay, asks him to take her to a cheap but respectable hotel, he might choose one where she will meet the love of her life; in either of these cases, he will probably then

disappear totally from the narrative, and should therefore not be named. If you do name very minor characters, it acts as a signal to your readers, telling them that, although the character may appear to be of no importance, in fact he or she is going to have a significant part to play, and that therefore the readers ought to try to remember the name.

5 *Sub-plots*

The Plot Thickens
What is a sub-plot? It's a story, just as a plot is, but of lesser importance than the main narrative.

Sub-plots add complications and interest to your story, which without them might seem rather thin. 'The plot thickens' is nowadays usually said in a somewhat humorous way, especially when a mysterious and pretty incredible development in a story is taking place. However, plots for novels *should* thicken – if they don't, you probably have insufficient material for a novel, and should be thinking more in terms of a short story.

The prime ingredient to add density to your plot will probably be the barriers which you put in your protagonist's way, but even if you contrive to construct a great many of them, unless they have some complexity, they are likely to become repetitive and will not bring about the changes of direction, the twists and turns which make a story interesting. So you will probably need to add in the thickening agent of sub-plots, which will not only have their own interest, but which will often bring the needed complications to those barriers.

Another good reason for including sub-plots is that without them the novel will be lacking in variety. It is not part of the human condition to be permanently single-minded – however closely a certain matter may engage our attention, after some time we are ready for a change, and other interests take over. In exactly the same way, when we are reading a novel we like to have our minds engaged in more than one aspect of the life it portrays. Sub-plots add the necessary variety, and often

do so by paralleling or contrasting with the main story, thus putting it into sharper relief.

Having said that, I must also admit that sub-plots are not an essential ingredient of the novel. Their absence will, however, only not be noticed if the main plot is of so complex a nature that it can carry the whole novel, providing continuing interest and sufficient variety to keep the reader satisfied.

Where Do Sub-plots Come From?

If you think again about John Donne's statement that 'no man is an Island', you will quickly realize that your principal character is not simply going to act and react in direct relationship with the people who surround him or her, but is affected by things that other people do in which he or she may not be closely involved. The secondary characters in your novel are therefore an important source of sub-plots, and this is why it is necessary when building up their characters to give them their own objectives and desires, quite apart from the fact that if you don't they will be incomplete.

Don't neglect the antagonist in this respect – his or her aims and ambitions are almost certainly the cause of the opposition he or she provides to the protagonist. You may be able to expand those ambitions so that a minor story develops from them, and if you can link them closely to the main story, you will have added a useful sub-plot.

At the same time, I must point out that it is not always easy to find an opportunity in your novel to explore the aims and ambitions of the supporting characters, simply because your story is so taken up with the protagonist. Or you might find that the sub-plots which you can develop come from what you might call third rank characters, rather than those who are almost as important as the hero or heroine. Don't worry if either of these things is true in your case – it isn't always those with the largest parts to play who have the most influence in a story, and in any case sub-plots don't *have* to be generated by any of the subsidiary characters, let alone all of them.

Indeed, an even better begetter of sub-plots is your

principal character. I have already suggested in Chapter 3 that in most cases the protagonist will have more than one ambition or goal. This is simply a reflection of real life. We are all concerned with self-preservation, which means providing ourselves, usually by means of paid employment, with food and shelter; we are all driven by the instinct to procreate, even if we see this not in terms of continuing the human race but simply as the need for sexual release; and most of us have a desire for companionship of a fairly stable nature – we want to love and to be loved; we may be in thrall to more than one of the seven deadly sins, and at the same time to a selection of virtues. Additionally, human beings have other interests – religion, politics, travel, sport, even hobbies like stamp-collecting – which may be less fundamental, but which can have a considerable influence on our lives. We are also all subject to and affected by worries and pressures of various kinds.

So your central character is likely to have more than one aim in life, and while the main ambition may be the real theme of the story, the other goals can provide sub-plots. For instance, although your heroine's principal objective is to find and marry Mr Right, she may also be concerned with her career, or with escaping from sexual harassment in the office, or with her deep desire to play the lead in the local amateur production of *Hedda Gabler*; or your hero's real goal may be to end up (against all the odds because there are other more likely candidates) as head of the firm, and the infighting in the business may be what your novel is really about, but at the same time he wants to marry his beautiful, intelligent and very sympathetic secretary, which will mean divorcing his wife.

The Essential Relevance of Sub-plots
It is vitally important that the sub-plots should be tied in to the main story. You should not include any material which does not really belong there and has no real part to play in the novel, whether it consists of characters, researched information, points of view which you wish to put across, or anything else at all. And this applies very

much to sub-plots. Beginners often go wrong on this point, and produce what I call 'detached' sub-plots. The fact that a sub-plot arises out of the interests of your principal character, as suggested in the last paragraph, is not a guarantee of its validity as a part of your story. It must have an effect on the main story. If, as a subsidiary theme, you make your principal character a fervent bridge player and he or she eventually succeeds in being picked for a national team, that may be an interesting topic for a sub-plot, but unless it is while playing bridge that he meets the woman who changes his life, or unless he misses an important business meeting because he is playing in a vital bridge tournament, and as a result loses the chance of promotion, and unless meeting the woman or losing the promotion are essential parts of the basic story-line, then bridge is a detached sub-plot, and should not be included.

It is always worth studying successful authors to see how they manage this kind of problem. If you were to look, for instance, at William Horwood's *Duncton Chronicles*, you would find that the series as a whole has as its single theme the victory of good over evil, and that each of the volumes has a central character and a main story. But a very large cast of supporting characters gives rise to many sub-plots – the love which develops between this one and that, the particular interests which drive them on, the different struggles which form part of the major conflict, the rivalries, the betrayals, and so on – but they all tie in to the principal theme and affect the central character.

Sub-plots can be of widely differing strengths – some are hardly more than blips on the chart of the main narrative, while others can be of very considerable importance, so that they are almost as strong as the main theme of the book. As an example of the weaker variety you can take almost any Dickens novel – his books are, of course, enormously rich in incident, and a great throng of carefully-drawn characters is presented, but although there are notable exceptions (for instance, the relationship between Nancy and Bill Sikes in *Oliver Twist*), quite often

the incidents and the subsidiary characters are introduced only because of the main character's experience of them, and they do not have real stories of their own. On the other hand, a novel in which the sub-plots are far more prominent, and indeed might be seen as the essence of the book, is Jeffrey Archer's *Not a Penny More, Not a Penny Less*. In that novel the stories of the individual victims taking their revenge could be classified as sub-plots, while the main plot – the swindle and the come-uppance of the swindler – is reduced to no more than a linking thread. Even in a case like that, the sub-plots do hang together and have an effect on each other and on the characters in them.

It is really a question of knitting two or more stories together. One of them will probably remain as the most dominant, but the others will be interwoven so closely that none could exist without the others. An excellent example can be found in *Pride and Prejudice*. The main story is, of course, concerned with Elizabeth Bennet and Mr Darcy – will they succeed in getting together despite all the misunderstandings and the efforts of others to keep them apart? – but there are several sub-plots, all beautifully knitted in to the main story. The most important of these is the parallel question of whether Jane Bennet and Mr Bingley will also end up with wedding bells in the offing, and this is a matter in which Elizabeth is much concerned, herself playing a part in their romance, and at one point finding Darcy to be even more objectionable than she thought because of what she believes he has said about her sister Jane. Then there are the problems presented by the appalling Mr Collins, which form a true sub-plot in that his wish to marry Elizabeth is not limited to his desire to find a wife, but is also tied into the threat which he holds over the Bennet family that he may dispossess them of all they own after Mr Bennet's death; and the Collins sub-plot continues because Charlotte Lucas, Elizabeth's friend and sometime confidante, is conveniently to hand to become his wife (releasing Elizabeth from his importunities), and that in turn leads to Elizabeth visiting Charlotte and while there

meeting the unforgettable Lady Catherine de Bourgh (who is not only Mr Collins' patroness but also Mr Darcy's aunt). A third substantial sub-plot involves Lydia Bennet and Wickham, and this affects Elizabeth not only because Lydia is her sister, but because Mr Darcy has previously been involved with the rascally Wickham. Finally, shadowy figures though they may be, the Misses Bingley, Darcy and de Bourgh are added in to the main thread of the novel.

(While on the subject of *Pride and Prejudice*, and even if I am now moving away for a moment from the subject of this chapter, I would like to suggest that the book might be regarded as an object lesson in plotting. It is a worthwhile exercise for any would-be novelist to analyse it in detail, observing how Jane Austen achieves her effects. Notice, for example, the way that she introduces the whole Bennet family in the first two chapters, but leaves us in no doubt that Elizabeth is the one whose story we are to follow, with Jane as the next most important character; see how she spaces out the ups and downs of the relationship between Elizabeth and Darcy; and admire her ability to twist the plot so that, while surprising the reader, it remains credible.)

To return to the question of sub-plots, and in contrast to *Pride and Prejudice*, consider Paul Scott's *Raj Quartet*. It would be extremely difficult to summarize the plot of any one of the four novels, let alone the *Quartet* as a whole, or, indeed, to say what the main story is, unless the books are defined simply as being concerned with the last days of British rule in India. The reason for this is that the *Quartet* does not have a single central character, but several, and its narrative has many main threads, involving different members of the large cast of characters. It could be said, in short, that each of the four books which make up the *Quartet* consists of nothing other than a series of sub-plots. But they are all cleverly linked and interwoven, so that they become dependent on each other. In many books the elimination of a sub-plot would cause the whole structure to collapse; in the *Raj Quartet* the problem would be less that of disintegration than of the sheer difficulty of

disentangling any one of the sub-plots from the rest of them and of eliminating all the references to and repercussions of that particular aspect of the work. That is how sub-plots should be written – so closely woven into the main fabric of the novel that it is impossible to cut them out.

Controlling the Sub-plots

Do remember, however, that we are talking of *sub*-plots. They are subsidiary, they are no more than adjuncts to the central narrative, and they must not become of such importance that they detract from your main story, or of such complexity that you have to desert the principal theme, and its characters, while you explore the people and circumstances of what should be a much less significant part of the novel.

If you find that a given sub-plot is growing in your mind so that it is becoming equal in stature to the story you started out to write, it is time to stop and take stock. It may be that your two narratives can exist happily alongside each other and together will form a novel which is, as you might say, all of a piece, but it is fairly difficult to bring this off successfully. It may work better, oddly enough, if you have brought more than two stories together, linking them closely in one narrative, as for example Jeffrey Archer did in the already quoted *Not a Penny More, Not a Penny Less*. If this is the kind of book that you want to write you will probably have been thinking along these lines right from the beginning. Nevertheless, since the whole business of plotting a novel, with the demands it makes upon your imagination and ingenuity, is not bound by any rules, it is possible that you will not discover that you really want to write a book of this kind until you have reached the stage of trying to work out your sub-plots.

On the other hand, when you stop to consider where you have got to, you may find that you have somehow engaged yourself on two novels simultaneously, and that they need disentangling from each other, one possibly being put on one side for later development into a different book. This discovery quite often happens to

beginners at a fairly late stage. Several chapters through the actual writing – perhaps more than half way towards the end – they suddenly realize that they have switched course and are not now working on the same book as they started with. One of the advantages of evolving a plot in some detail before you begin is that you can avoid this trap. Nevertheless, even at plotting stage, and certainly later when you are writing, it is worth stopping every so often to ask yourself what story (or perhaps, even better, *whose* story) you are writing – and do make sure that you get the right answer.

6 Backgrounds

Active and Passive Backgrounds

The background to a story always exerts some influence over the plot, but the extent of that influence can vary enormously. I think of backgrounds as either passive or active. A passive background is one which, while it may provide a considerable amount of atmosphere, could be changed without affecting the basic story. An active background cannot be altered without destroying the book.

Where It All Takes Place

When we talk of backgrounds, people usually think first of the physical setting of the story, the place or places where it all happens. Very often the location is a passive influence. Think, for instance, of *Wuthering Heights*. You may feel that the setting is a vital part of the story, but if you examine the novel closely you will find that, although the desolate Yorkshire moors add greatly to the atmosphere, the story *could* have taken place in a somewhat similar setting elsewhere – on Dartmoor, perhaps, or in the highlands of Scotland. The novel would not be the same, of course, but my point is that when we read *Wuthering Heights*, although we may be aware of the scene, what we are really concerned with is the relationships between Heathcliff and Catherine and all the others who play a role in the tragedy. The background does not basically alter the story. Or look at *Oliver Twist*. It is possibly even more firmly set in London than *Wuthering Heights* is in Yorkshire, but it *could* have been given a background of any large English city in the nineteenth century.

It is not only, of course, a question of the use which may be made of the physical location and its scenery in the telling of the story; we must not forget the influence that the background has had on the characters themselves long before the story begins and which it continues to have throughout the telling of the tale. If Catherine Earnshaw had been a Scot, her love for Heathcliff would have been just as passionate and just as doomed, but somehow her Scottishness would have altered her personality, even if only very subtly, and the story would have changed. The villains of *Oliver Twist* are Londoners through and through. The places where we live, and especially where we are brought up, have a strong effect on us. This fact needs particularly to be kept in mind if you are writing a novel set in the nineteenth century or earlier, when people were far less cosmopolitan and far less likely to move far from their place of birth. Nevertheless, these influences are still pretty passive.

You may feel that even if you accept my argument, however doubtfully, it would not extend to changing the country – *Wuthering Heights* and *Oliver Twist* are quintessentially English. But are they – or are they international because they are concerned with human emotions which are shared world-wide? And wouldn't *Madame Bovary* still work if it were transferred to an English provincial town? There may be difficulties stemming from the generally accepted perceptions of national characteristics – perhaps Nabokov could not have set *Lolita* in his native Russia, let alone in England – but while it might be easier to move *Wuthering Heights* to Devon or Scotland than to Lithuania or Italy, Emily Brontë's intense concentration on archetypical human beings would make it possible.

Looking for a location which plays a more active part in a novel, we can readily think of books like Graham Greene's *Our Man in Havana*, or James Clavell's novels with their settings in the Far East, and many, many others. And if you move to imaginary settings, the background is likely to be a highly active ingredient in the plot – think of Conan Doyle's *The Lost World*, or of almost any science fiction novel.

The Social Background

Background is not simply a matter of physical location. The social standing of the characters, for instance, is invariably an active constituent of the plot. Catherine Earnshaw comes from a well-to-do family – her story would have been very different if she had been born into the servant class. The different social backgrounds of Mr Brownlow and Fagin are used to great effect in *Oliver Twist*. The huge cast of characters in *War and Peace* is composed almost entirely of aristocrats and/or army officers. The social background is an essential part of the story in a novel like *Nice Work* by David Lodge, or the latest P.D. James or Ruth Rendell murder mystery. We are formed not only by the genes transmitted to us by our parents, but by the kind of upbringing and education we receive, by the social milieu in which we find ourselves – and the same is true for the characters in any novel, so if you were to try to alter their social backgrounds you would find that you were radically changing their stories.

Other Forms of Background

Historical events are often used as the backgrounds for novels, and again are usually pretty active ingredients, although the actual influence on the plot can vary. For instance, the stories in all war novels are clearly affected by the fact of the war in which they are set, but some are tied specifically to one carefully documented action – the Arnhem landings in World War II, for instance – while others merely use whichever war it may be as a general background.

Many novels, especially popular in recent times, have taken some kind of industry as a background, and have used the business as so active an ingredient of the plot that it has almost the status of a major character, as it were. A good example of this is to be found in Donna Baker's trilogy, *Crystal, Black Cameo*, and *Chalice*, which together make up 'The Glassmakers Saga', and in which all the processes of manufacturing high-quality cut glass are an integral part.

Historical Backgrounds

The period in which a novel is set may also be either active or passive. In a contemporary story it is likely to be a passive influence, taken for granted, as it were, but in a historical novel (and I include in that term any novel set over thirty or forty years ago), the period is an essential part of the narrative, providing a background which affects the characters in many ways. If this is not so, then the novelist should be wondering why he or she has chosen that particular time in which to set the story.

It is not, of course, only a matter of a period background which is always there throughout the story. The plot may also be affected because you, and your characters, cannot ignore specific outside events. If you are writing a historical novel set in medieval times, it is conceivable that a small community could exist in total isolation, untouched by wars or the raising of taxes or plagues, but even a thousand years ago few people were as cut off from the rest of the world as that – a social system was in existence which, in its simplest terms, put peasants and other underlings under the control of feudal lords, and feudal lords were themselves kept under control by the rulers of the land. Vagabonds and outlaws may have been outside this system, but even they could not escape entirely from the knowledge and the effect of outside events. Very often these historical events can be of considerable help in developing your plot by the way in which they affect your characters.

The Time-span of the Novel

The time-span of your story is another facet of the background which may influence the plot. If the story covers several years, there will be the effect of age upon your characters, and undoubtedly various historical events will take place and demand to be at least mentioned. In a shorter period, you may have to consider the seasons and the weather. The weather, incidentally, is often used to advance a story – the sudden shower of rain which allows the hero and heroine to meet when they both take shelter from it, or the snow which maroons a

group of people while a murder is committed and solved, or the monsoon in which a ship founders, taking with it the lives of everyone aboard save the hero and the villain, or a fortune in gold, or the secret papers.

Knowing the Background
Whatever the various backgrounds of your novel may be, you need to know them thoroughly.

Take, for instance, the location of your story. You will want to be sufficiently familiar with it to be able to convey its atmosphere, but you will also have to know its topography in considerable detail. If your book is set in a real country, city, town or village, it will almost certainly be important to be aware of exactly where it is in relation to other places – how long it will take to get to another country, perhaps, the route you would travel from, say, the Bank of England to Buckingham Palace (and that would possibly include, if your characters were travelling by car, some knowledge of one-way systems and the like), where the pub is in relation to the church, and so on. It is essential to get things right. It is equally important, if your setting is imaginary, to work it out in detail – is it possible for the murderer to walk from the manor house to the village shop and back within the ten minute period which is unaccounted for? – and you will probably find it worth your while to draw yourself maps of all the areas that your story covers.

As for the social background, especially if you are writing a historical novel, you will probably need to become expert in a whole string of things relevant to the particular period with which you are concerned – class attitudes at the time, manners, speech patterns, the position of women in society, working conditions, education, religious beliefs, food, clothing, illness, transport, money, the speed with which news travels, etc., etc.

In a period or historical novel, you should know the history of the times you are writing about, because of the impact which it may have on your characters. In one of my own novels, for instance, set in England in the

eighteen-nineties, I could not ignore the Boer War, which gave me a considerable problem. The war played a part in the story, and enabled me to dispose of a character that I wanted to get rid of (wars and disasters of various kinds are very useful for killing off characters who would otherwise be in the way), but, oh, how I wished, because of other elements of my story, that I could have put the war off for a couple of years. Instead, I had to juggle the timing of the private, as opposed to the public, events of the novel.

It is easily possible, of course, to write a novel in which outside ,historical events have no place whatsoever, because the time-span of the book is so short that you can avoid any awkward dates. But even in the contemporary novel you will have to be conscious of the social background, and if you write a story set in the future, you will have to invent the outside circumstances which surround your characters.

Novels which have a carefully researched background and which give their readers information about some subject or other are very popular, and this includes many of those with an industrial background, which I have already mentioned. No one would think of calling them educational books, even if that is in part what they are. The instructional material in them is, or should be, so well integrated into the text that it does not appear to be in any way separate from the story, but actually forms a part of it. A novelist must never lecture the reader, or set out to teach in a noticeable way.

All the requirements that we have been discussing so far have been concerned with backgrounds which are there for a substantial part of your novel. You may, however, need a particular setting for a small part of the story only. Suppose, for instance, that you want your hero to go to India briefly for some reason – let us say that he is going there on business. The Indian scene may have great significance in your story, or so little that we don't actually see the hero there, but the business background which forces him to go there cannot be completely ignored. You do not need to give an elaborate explanation of the visit – if

you don't want to get involved in any description of what kind of work he is engaged in, you could simply say that his firm sends him to India on a sales trip, and leave it at that, without even explaining what he is supposed to sell. If his business interests are irrelevant to your story, that is fair enough; you may find, however, that it is all going to sound a little thin to your reader, and without making it into a major part of your story, you may wish to learn enough about a particular business to involve your hero in it, and to be able to give a reasonable explanation for, and some details of, his journey.

Research
What all this means, of course, is that you will have to do quite a lot of research – unless you are writing an autobiographical novel, or one with a background in which you are already an expert. Even then you may need to look up various details. Research is for many novelists a continuing process – they continue to research while they are actually writing their story, partly because they may not know for certain until they reach a particularly point in the novel that they need to know, for example, what route a number 6 bus follows, or how much gin you could get for a penny in 1873, or whether you could dine on rabbit in this country before the Norman Conquest (you couldn't – as Geoffrey Trease found out when a young fan wrote in to complain about this point in one of his otherwise splendid stories for children).

John Creasey, the prolific author of thrillers, used to say, 'Write first; research later.' That is all very well if you are simply uncertain about whether it's a number 6 bus or a 9. If the information you need is rather more complex than that, it will unquestionably be worth doing a great deal of your research at a very early stage and certainly before you have completed the basic plotting of your novel. I would suggest that you should make a list of everything, in detail, that you need to know, and then methodically set about finding it all out. Do this as soon as you possibly can because you may, in the course of your reading, discover something which will have a major effect upon

your story, or which will spark off a story that you didn't even know that you wanted to write. An example of the first possibility is given in the later section of this book devoted to my novel, *Mario's Vineyard*. As for a whole story arising from a single discovered fact, when Barbara Willard learned that a family of seventeenth-century vagrants apprehended by the local authorities would often be split up, parents, children and even small babies being returned to the different villages where they had been born, it gave her the idea for a book called *The Queen of the Pharisees' Children*, which won the Whitbread Prize for the best children's book of its year.

The research will probably have to be pretty wide, but you will find that books on every conceivable subject abound – social histories are particularly useful, especially if you are writing period fiction, and so are costume books. You can also usefully study old photographs and, going farther back, old paintings, and a discriminating eye on the television set can often provide interesting details (though it may be as well to verify elsewhere what you have seen). Librarians are usually very ready to help – they are specialists in the retrieval of knowledge, and most of them would far rather assist you in your research than spend their time collecting reservation fees for the latest bestseller. There are also Public Record Offices, both national and county, and museums and tourist offices, and so on. It is easy to discover just what information is available, and one of the best ways of doing so is to get a copy of Ann Hoffmann's excellent book *Research for Writers*, which is extremely helpful in guiding you towards an enormous number of sources of information.

Yet another invaluable and sometimes unrecognized way in which authors can get hold of the details that they need is by asking their relations, friends and acquaintances about what they want to know. With very few exceptions, people like to be asked about their experiences, their occupations, their specialist hobbies, their expertise, and the like, and if you show your genuine interest in what they say, and if you stimulate them by asking the right sort of question, they will pour out an

apparently never-ending stream of useful information. This works particularly well if you tell them that you need these details because you are writing a book – to the public at large authors, even those who are struggling and unknown, seem to have an aura of glamour, and however undeserved this may be, it will often make your interlocutor feel that he or she is not only dealing with someone who is interestingly different, but is also taking a small part in a creative process, which is something that all human beings admire, enjoy and sometimes envy.

If all else fails and you are still unable to find out those essential facts needed for your novel it is perhaps worth knowing that there are several people who make their living from doing research for other writers – Ann Hoffmann herself was one, but has, alas, now given up that business. Where do you find these researchers? Well, it takes a bit of research to dig them out, but you will often find their advertisements in the small ads columns of magazines for writers.

Backgrounds – place, time, events, industries, and the history behind them – are like characters in that it is essential for the novelist to know them as fully as possible when working out the plot and when actually writing the novel. Just as you don't necessarily put everything you know about a character into your story, equally you don't put all your research in unless it is relevant. As the novelist and publisher Diane Pearson says, 'Research is like manure – a little here and there makes everything blossom and grow, but in large lumps it is horrid.'

7 Twists and Turns

Suspense

By now, if you have been trying to work out a plot by following the advice so far given in this book, you should have made considerable progress. You will, I hope, have decided on the kind of novel you want to write, and have found the originating spark which has started the wheels turning in your brain. You will have got to know your principal character in depth, and will have assembled a supporting cast of his or her relations, friends and acquaintances, including an antagonist, and you may have begun to work out the parts they will play and whether any sub-plots will be developed from them. You will have considered the point of view of the story (first person, God's-eye view, or third person through the eyes of the principal character). The background will probably be reasonably clear in your mind, and you may even have started on any necessary research. Most importantly, you will probably have a firm idea of your protagonist's aims and ambitions, you will know what his or her main goal is, and perhaps you will have thought of some at least of the barriers which will be placed in the way of achieving that goal, of how they are to be overcome, and with what results.

Those barriers will provide you with drama, because they inevitably cause conflict. As any student of Creative Writing will have heard time and time again, conflict is the essence of drama. Another good definition is that conflict is a state of affairs which keeps the main characters from enjoying themselves. The conflict which we are discussing arises almost always (and certainly most effectively)

between characters – obviously between the hero or heroine on the one side and the antagonist on the other, but also sometimes between the hero and heroine themselves, or between friends, or it may exist with particularly telling effect *within* the main character, who has perhaps to make a difficult choice between right and wrong, or to decide whether or not to take a course of action which may simultaneously serve his or her interests in one way and harm them in another.

It is not too difficult to work out occasions for conflict in your plot – the problem is to find satisfactory ways of solving them. You have to ask yourself just what is going to keep your readers reading. Is everything so predictable that they will be able to guess not only the outcome of every piece of conflict you have inserted, but also how it will be achieved? This problem is probably at its most acute in the romantic novel – the reader knows that the heroine is going to end up in Mr Right's arms, so why bother to read the story at all? The answer is of course that the author of such a story will do everything possible to make it seem highly improbable that the heroine will achieve her objective, using a number of different devices, such as the apparent arrogance of the hero, the heroine's misplaced pride, misunderstandings of various sorts, the Other Woman, and so on, not forgetting the influence of outside events (think, for instance, of the havoc that could be caused to a relationship by the cancellation of a train, resulting in a failure to keep an appointment which had been the subject of a solemn promise).

What we are talking about is suspense. Give your principal character a major problem, set him or her in some kind of crisis situation, and then erect a really difficult barrier in the way of his or her ambition, and your reader will want to know what happens next. This is a basic fact of human nature – provided that we have an interest in the person concerned (and in a book this means that we are identifying with the protagonist), we are always interested in the solution to that individual's problems. How does she get herself out of that awful mess? What will he say when he discovers the dreadful

truth? The answers to such questions are secrets until the author reveals the solutions, and we all enjoy secrets. It goes back to the game that adults play with children – 'Guess what I'm holding in my hand' – in which you create a suspense which continues until you open your hand and show what is in it. But do note that I said 'that *awful* mess', 'the *dreadful* truth' – a mess needs to be awful, the truth needs to be dreadful because it heightens the reader's interest. If the problem is a minor one, the reader may not care.

Let me repeat that suspense can exist in a very strong degree despite the fact that readers are pretty sure of how the book will end. The romantic novel will finish with wedding bells, the thriller will see the baddies get their come-uppance, and we can be sure that Lady Mary Whatshername does not succeed in her plan of marrying Henry VIII and becoming Queen of England. But on the way to those predictable endings are all kinds of developments the outcome of which we do not know, and that is where the suspense is to be found.

Putting Twists Into the Plot

When the adult asks the child to guess what is in his or her hand, it is not simply a question of finding out – it is also a matter of being surprised by the discovery. All those complications which a romantic novelist might add in to a basic girl-gets-boy plot must have a strong element of surprise. And the same thing applies whatever the genre.

So how do you insert this element of surprise into your story? It is not easy to answer, because it depends on what sort of story you are telling and, especially, on the characters. It can come, of course, either from the nature of the barriers you erect or from the solutions that are found, or from both. Try, when you are working out your story and are constantly asking yourself 'How can I make this happen?', to look carefully at all the 'What if ...?' suggestions that you give yourself, reject all those that are ordinary, pedestrian, and try to think of less predictable alternatives. If you have already settled on some outcome or other, ask yourself whether it is sufficiently intriguing,

or whether it might be possible to reach a more unexpected result. Try to look at things from a different angle, turn ideas on their heads, give your imagination free rein.

Some of these highly desirable and surprising twists in the plot can quite legitimately be brought about by outside events – the hero being unexpectedly sent to India by his firm, for instance – but it is more satisfactory when they arise out of the characters. Characters are simply people, and we all know how unpredictable and unreliable people can be. We all have occasion now and then to say something like, 'I never thought she'd take that attitude – that's the last thing I would have expected,' or 'It's so unlike him to forget, especially when he'd promised.' Of course, if your central character is a mouse-like creature who lives by routine and who never has an imaginative or innovative idea, like Augustus Simpkins in the story that Pamela Frankau tells, you may have some difficulty in making him act in an unpredictable way; on the other hand, however, if you can devise an acceptable reason for him to go off the rails, the twist is going to be all the more effective.

It is absolutely essential, however, that if problems are caused by outside events, they should not be totally unreasonable. Equally, whatever strange, unexpected things the people in your story do should be logical for the characters concerned. The others in the story can be completely flabbergasted by the aberrant speech or actions of the characters concerned, but your readers, while still being surprised, must be able to accept the possibility that they would behave in that way. In other words, although what they have said or done is apparently entirely 'out of character', in fact it is 'in character' if you know the person really deeply. That means that you will somehow have to indicate to the reader not only that the characters are more complex than they may appear to their relations, friends and acquaintances in the story, but that the seeds of whatever form of strange behaviour may be involved are there, waiting to germinate. This might be described as playing fair with your readers; you have to do it very

subtly, because if it is too obvious the element of surprise is lost, but if you don't prepare the way, you risk losing your readers' confidence in the truth of your story.

In my Creative Writing classes, I usually refer to the insertion of early clues to what will happen later as 'little clouds'. The allusion is to the 'cloud, no bigger than a man's hand,' which was seen by Elijah's servant (1 *Kings* 18) and which grew into a heavy rainstorm. Chekhov gave the same sort of advice when he said, 'If you're going to fire a gun in the third act, your audience must see it loaded in the first.' Little clouds are like the clues in a detective story – hints which you disguise and drop in as unnoticeably as possible, but which readers will remember when those hints come to fruition. So, for example, at an early stage in the story about meek-and-mild, wouldn't-hurt-a-fly Augustus Simpkins you might show him on his own in his garden shed making an awful mess of nailing something together; he snarls out a string of swear-words and flings the hammer away in a fury before storming out of his shed; but as he steps out into the garden, he resumes his normal quiet, gentle attitude. You will not only have shown that he is capable of violent anger, thus preparing the ground for the later revelations that he is contemplating murder, but you will have demonstrated that he is adept at hiding his feelings in public.

Little clouds are immensely useful, but you must be careful not to put something in which the reader will recognize as a clue of some kind, but which you do not follow up. Suppose, for example, that you describe dear old Augustus setting off for his office, carrying his brief-case and, even on a cloudless day, his neatly furled umbrella. That's all right. But if he hasn't got the umbrella and goes back to the house for it, even though there's no sign of rain, you may have put that in simply to suggest how much a creature of habit he is, but your reader will almost certainly expect something to happen concerning that umbrella, and if it doesn't there will be a sense of disappointment, of something unfulfilled.

How Not to Twist the Plot

It is because you need to retain the respect as well as the interest of your readers that you should try to avoid introducing an element of surprise by the use of coincidence. This is a pity. In real life we often come up against coincidence, and always enjoy it when we do, even if it is sometimes a bit of a strain to connect two bits of information in this category: 'I discovered that Helen's mother went to the same school as my cousin's friend's father – isn't that a strange coincidence?' But however much we may like real-life coincidences, in fiction they are anathema, because they seem like cheating on the author's part. Readers want surprises which are logical and which are caused by something more than mere chance.

It is also completely unacceptable to use a *deus ex machina*. 'The god out of the machine' was a device used in the ancient Greek theatre when, at the end of a play, an actor representing a god from Olympus would descend to the stage via a kind of crane and would then sort out all the problems of the mortals in the drama. So don't even think of suddenly introducing in the final chapter the previously-unheard-of, long-lost Uncle Bluey from Australia, whose wealth solves all the problems of the impecunious hero and heroine. If you must use Uncle Bluey, then he has to be involved in the story at an earlier juncture – not just mentioned, but actually playing an influential part in the plot. Even then, you should avoid letting Uncle Bluey's money solve the problems – whenever possible, heroes and heroines should find their own way out of their difficulties and achieve success by their own efforts.

As for dreams, since we are all amateur psychologists nowadays and know that they are extremely revealing of our secret thoughts and wishes, it may be legitimate to include a dream for one of your main characters in order to tell the reader something about him or her which might not be immediately obvious and which you can do in a subtle and interesting way. On the other hand, if you describe a dream without revealing that it *is* a dream, not

so as to reveal character, but with the intention of surprising your readers when you eventually disclose the truth, I would advise most strongly against the device.

Readers have a great deal of patience. They will accept the fact that the author sometimes plays games with them, by withholding some essential piece of information until a later time, or at least, not revealing it directly. That sort of thing is quite acceptable, provided that some faint hint of the surprise is given in advance, or at least that it is logical, because the author is playing fair. What readers don't like is being tricked in a way that they consider cheating. Coincidences, the *deus ex machina*, the it-was-only-a-dream technique all fall into that category, so they are to be avoided wherever possible, as are any other cheap devices – such as twins (when you don't tell us that they *are* twins – and sometimes even if you do), or the insanity of a major character (which again you don't reveal until the end of the book, when it becomes apparent that you have used it to cover up the fact that parts of your plot would be otherwise totally unbelievable).

The Suspension of Disbelief

My strictures on the use of devices such as coincidence and the *deus ex machina* do not mean, of course, that you cannot successfully tell a story part or the whole of which is pretty incredible. Readers are often prepared to suspend disbelief, provided that the author does not strain their credulity too far, too often and for too long; they are not, like the White Queen, practised at believing six impossible things before breakfast – two, perhaps, but not six. But they will accept, for instance, the kind of complicated situation which develops from an initial misunderstanding which could have been easily resolved if only the main parties to the misunderstanding had bothered at the time to give a simple explanation of their words or action; from that point on, however, the readers will expect the story to proceed without using a similar device again. It is rather like the Oscar Wilde joke in *The Importance of Being Earnest*, 'To lose one parent, Mr Worthing, may be regarded as a misfortune; to lose both looks like carelessness.' – to use

one misunderstanding may be regarded as reasonable; to use two looks like poor plotting.

Variety

Another key ingredient in your novel is variety – variety particularly in what happens to your protagonist and in the mood of the story as a whole.

Every conquest of a barrier which you have placed in your central character's way is inevitably something of a success for him or her, but should you present a whole sequence of such conquests as triumphs, they will begin not only to make it sound as though victory is inevitable, but to be boring. The principal character should have disasters as well as triumphs, and sometimes an apparent triumph may turn out to be only a partial success. And from time to time it may be possible for your hero or heroine to take the alternative course of running round the barrier instead of tackling it head on.

As for the mood of the novel as a whole, it too needs a certain amount of change. A story that meanders along without any drama or tension is going to be very dull, but something which is tense from beginning to end is likely to lose a great deal of its effect because the excitement is unrelenting. You need to give your reader a chance to relax every now and then before you pile the pressure on again. No doubt you are aware of Shakespeare's use in so many of his plays of 'comic relief'. Master William knew what he was about – the release of laughter at a particular point in a play not only prevented the drama from becoming over-intense, but also actually increased the impact of what was to follow. The same device can be used equally effectively in a novel.

All sorts of methods are available to you for the periodic relief of tension. Humour is one of the most effective ways of varying the mood because it can provide a really strong contrast to the rest of the story. (It can also, by the way, be very helpful to give your central character a sense of humour, which will make him or her seem both human and likeable, and will diminish any tendency to pomposity.) The introduction of a sex interest into a

thriller is a good example of another way of tackling this problem – while the hero is engaged in love-making, the chase or the hunt for the enemy agent, or whatever it may be, is temporarily forgotten, and the mood has changed. It does not have to be a torrid sex scene, but the mere presence of a woman will give a different dimension to the story, which will tend otherwise to be almost exclusively male-orientated. Of course, in such a case the hero's interest in the female character might be described as a sub-plot, and, as has already been seen, one of the functions of a sub-plot is to lend variety of interest and mood to the main story.

8 *Putting It All Together*

The Plot as a Physical Shape

As we all know, real life is messy, untidy and unpredictable. While a plot too should be unpredictable to the extent that the reader cannot be sure of what is going to happen next, it must not be lacking in structure. It is contrived – you might say it is man-made and artificial – for the purpose of telling an interesting story.

At an earlier point in this book I compared a work of fiction to a painting. Ask any artist about a painting of any kind and you will soon be listening to a mini-lecture on the *composition* of the work – that is to say, the basic elements of the picture, the way they have been placed in relation to each other, the degree of emphasis that each has been given, and the overall effect. Another word which might be used instead of 'composition' in this context is *shape*.

Events in the real world tend to lack much sense of shape, but it is, or should be, very apparent in a plot. I like to talk of *shape* in relation to plots, because it suggests something visible. You could make a graph of a plot: along the base line you would mark off the chapters or the main incidents in the story, while the vertical would be divided into degrees of interest and excitement. What you should produce is a curve rising steadily to the final climax of the story. It won't be a smooth curve – there will be ups and downs as the tension is increased or slackened off, and while the major scenes in the story will provide excitement, and therefore peaks in the line, the introduction of a sub-plot may result in a little dip until the impact of that part of the story is fully understood, at

which point, like a tributary joining a river, it will probably push the interest-level to a new height. I would also like to point out, if I am not straining the metaphor too much, that the peaks in your story should be small plateaus, rather than sharp cones, which is to say that the more dramatic scenes in the story should be given time and space to make their effect. Most of us tend to over-write, which is to be avoided, but, while the style must remain economical, a big scene should not be skimped.

I have already mentioned variety of mood, which will itself have an effect on the graph, but there are two other elements which also add variety and which can have a major influence on the tension.

Action or Narration

A maxim which most tutors of Creative Writing will offer to their pupils from time to time is 'Show, don't tell', or, as an alternative, 'Make a scene of it.' In the terms which those tutors use, a scene, or showing, is action, while telling is narration.

'Action', in this sense does not necessarily mean physical action or even a bitter but non-physically violent confrontation between two people. It can be simply a quiet conversation, and even if it does involve movement, it need not be in any way violent. 'Action' in this context means only that you describe the happening directly while it is going on, and metaphorically blow by blow, instead of reporting it in 'narration', indirectly, after the event, and usually in summary form.

Action is always more exciting, more involving, more immediate than narration. It brings the story to life in front of the reader's eyes, and usually involves a considerable amount of dialogue, which not only advances the story, but is revealing of character (and when Alice decided that her sister's book was dull because it contained no pictures or conversation, she was really saying that it had no pictures or *action*).

Is action always preferable to narration? No. It should certainly be used for all the high spots in your story, the moments of excitement and tension, the points when

something of major significance occurs, the crises and their resolution. So you don't tell us that the hero and heroine quarrel, you show them quarrelling; you don't say that the battle was a violent one, you make us feel and hear and smell and *see* it as it happens; you don't tell us that the victims escaped from the screw-down ceiling by falling into the cellar, you show the ceiling gradually coming down and we hear what the victims and the murderer say, and then you describe how the floor collapses, and we see the intended victims falling through (and the murderer perhaps being crushed by his own device), and it is all happening there in front of us.

But if you use nothing but action you lose a great deal of its effect. Contrast is needed, and is provided by narration, which you use to link the action scenes in the novel and to put across essential background information. Just as 'action' in this context need not involve physical activity, so 'narration' is not always confined to occasions when nothing much is happening – occasionally it can be used effectively to describe something after the event, but it is almost invariably advisable, if something of importance *is* happening, to use action. Narration has one great advantage over action – it is very much more economical. You could devote page after exciting page to a dispute shown in action; in narration you could cover the entire scene in one brief sentence.

Varying the Pace

The alternation of action and narration will automatically result in a change of pace, which is desirable to bring a feeling of variety to your story. But the pace can also vary between one action scene and another, or between one section of narration and another, and indeed can alter within a scene or section, and you should always be looking for opportunities for adding this kind of contrast. Much of it should come naturally – if the event you are putting on to paper is fast-moving and violent, you are likely to write the scene at a faster pace than if it were a more leisurely happening.

It may be felt that action as opposed to narration and

variation of pace are matters of writing technique and style, rather than anything to do with plotting, and the same criticism may be applied to other matters in this chapter. I believe, however, that you need to work out your plot in considerable detail, and that the detail should include the concept of variety in the story, whether it comes from the introduction of sub-plots, from changes of mood, from contrasts between action and narration, from variations of pace, or from different tale-telling techniques such as the use of letters or the introduction of a stream-of-consciousness section. It should all be deliberate, and it is all part of plotting.

Beginnings

At what point in the story is your novel going to begin? And how?

If you look at the novels which we call 'classics', most of which come from the nineteenth century, you will find that they usually begin in a pretty leisurely sort of way. They describe the scene, or perhaps they tell you, before they even get to the hero, who his parents and grandparents were and what sort of circumstances they lived in, and so on and so forth. Nowadays readers expect you to get on with it much more quickly than that. They want to plunge into the story straight away. They want to be … interested? Intrigued? Yes, but more than that. They want to be *hooked* – so interested, so intrigued that they go on reading as a matter of some urgency. Several things can contribute to the achievement of this happy effect on your reader: it is an advantage if your principal character is the sort of person with whom the reader can immediately identify; it helps if you establish quickly that the main theme of your book is at least interesting, and preferably quite unusual; and the ability of a really good writer to make a reader enthusiastic after the first few sentences simply by the quality of the prose should never be underrated. There are other techniques, too.

One of the things that all Creative Writing tutors will mention is the importance of beginning the book with an exciting sentence. Here are three which are, in my

opinion, excellent examples of how to intrigue your reader from the very start:

'Hale knew, before he had been in Brighton three hours, that they meant to murder him.'

(*Brighton Rock*, Graham Greene)

'It was at a love-spinning that I saw Kester first.'

(*Precious Bane*, Mary Webb)

' "Take my camel, dear," said my aunt Dot as she climbed down from this animal on her return from High Mass.'

(*The Towers of Trebizond*, Rose Macaulay)

You should always strive to make the first sentence, or at least the first paragraph, raise questions in the reader's mind: who is Hale? why are they going to murder him? why has he come to Brighton? No doubt you will be able to supply the questions posed in the other two openings.

I also like the idea of introducing the central character of the novel in the first lines and before any other persons have been named – this amounts to telling your readers right from the start which character they are supposed to be interested in. Additionally it is advisable to give some indication of the period and setting as soon as you can.

All these tips are worth noting – they really do work – but the most valuable advice of all (and we are now concerned with a matter which really is part of plotting rather than writing technique) is to begin your novel just before, or at the beginning of, or even in the middle of a point of crisis. And since it is a point of crisis, it will of course be told in action, rather than narration, so you will plunge your readers straight into a dramatic scene. Don't worry if it will not immediately be clear to them what is going on – while you must not keep them waiting too long before clarifying the situation, they will not mind a little puzzlement, and indeed will probably enjoy the fact that there are questions in their minds: what's going on? who are these people? why is Jane/John so happy/miserable/frightened/angry?

At the same time, I think you must beware of making your readers ask themselves too many questions at the beginning, so I would add one other necessary quality to

the opening, and that is a degree of simplicity. Don't introduce too many characters too quickly, don't confront your readers with so complex a plot or so much background information that they can't easily take it all in.

Endings

The way your novel finishes is immensely important, and I believe firmly that the author should be certain about the ending at a very early stage, because it can have a considerable influence on the plot as a whole. It is like going out in the car – if you know where you are going, you can plan the route; if you don't, you may easily finish by going nowhere.

So what makes a satisfactory ending? Firstly, it must of course be logical in relation to the rest of the plot, and must arise naturally from what has gone before. Secondly, if you are aiming at a popular market (which does not necessarily mean the lowest, least intelligent part of the market, but simply a wide readership), it really must be an *ending* – it should not finish with everything up in the air, but should tie up the loose ends and provide a conclusion that will leave readers with a feeling of completeness. This does not mean that every single loose end has to be firmly tied – you don't have to pair off all the women with a suitable man, nor do you have to tell us what happens to some of the minor characters. But don't leave any major puzzles unresolved, especially if such matters formed an important part of the story.

There is no rule which says that you have to have a happy ending, although most successful novels end on an up beat rather than a down beat note. But if you want to leave your heroine sadder but wiser, or if you want to kill off your hero on the final page, there is nothing to stop you, and of course there have been many books which, following the traditions of the tragedies which form the most respected part of the classical drama, have ended with sorrow and death.

Brian Stableford, in *The Way to Write Science Fiction*, talks of 'the notion of moral order,' pointing out that while it is usually missing in the real world, it is normally present in

fiction. Therefore in novels justice must be done, which does not necessarily or only mean that the baddies should receive their come-uppance, and that the hero should win the girl and fame and fortune – except that we all really like such an ending, provided of course that it is a logical outcome of what has gone before. One of the principal reasons given for the success of fiction is that it provides an escape from the real world, not only because we can experience vicariously a life totally different from our own, but because for a time we can live in a world which has the moral order of which Brian Stableford speaks – a world in which we can rely on Good to conquer Evil.

On a purely practical note, when you are plotting the ending of your book, the sorting out of all the complications, the rewarding of good and the punishment of evil, do make sure that you don't rush things too much. Reading first novels one sometimes finds that the last chapter seems to move at breakneck speed while the author ties up all the ends, as though he or she had grown tired of writing and wanted to finish it as quickly as possible. Take your time.

On the other hand, do end the book where it should end, and don't go on with explanations, or bits of additional information which the reader really doesn't need. If you take a conventional romance, for instance, it should almost certainly finish with the heroine's acceptance of the hero's proposal of marriage, and there is no need to tell us about the wedding, or where the happy couple went for the honeymoon, or even how many children they had. And don't end, if you can avoid it, with a final chapter which begins with the hero or heroine realizing all his or her ambitions and then go on to tell us about the minor characters – get them out of the way first, so that we end with the stars rather than the bit-players.

Middles

The fact that 'Middles' comes after 'Beginnings' and 'Endings', rather than between them, is quite deliberate. It is only when you know where you will begin and where you will end that you can really work out what goes in

between – or rather, not so much *what* goes in between, but *how* it will be arranged.

Timing is of considerable importance. I do not mean the chronology of the story, which I will come to later, but timing in relation to what you tell your reader. How much will you reveal immediately, and how much will you conceal for later release, and when will the release be? When will you introduce your sub-plots? When will you break away from one thread of your story to examine another? Many questions of this sort, concerned with the management of your material, have to be answered.

The high spots of your story, the major scenes in it, will very often be connected with the barriers that you have put in the way of your principal character's aims and ambitions. They will need to be spaced out as far as the story allows, so that you do not, for instance, get all the excitement in the first half of the book, and very little in the second (if you find yourself in that situation, incidentally, something has gone fairly seriously wrong, and you will need to do some rethinking – perhaps the book ought to finish at the halfway point). You will also need to ensure that the sub-plots are interwoven with the main story to form an acceptable pattern, so that we don't lose sight of the major theme while you are exploring a subsidiary tale. You must aim for a balance.

At this stage too you may begin to think of your plot in terms of chapters. It is certainly not essential to divide your story, as the late John Braine absurdly insisted in his book *Writing a Novel*, into at least twenty chapters; you can have any number you like, from one upwards (though readers do like fairly regular breaks). The actual number of chapters will probably be dictated by your plot, which may divide itself up quite naturally as you insert narration between the action scenes or knit in the sub-plots. The divisions produced by this process will often be of differing natures – sometimes a major break, possibly with a change of scene, of time, of characters, which may well signify the end of a chapter; other pauses in your narrative may be of much less significance, demanding no more than a blank line within a chapter to suggest a change of

focus. Very often the chapters will have a close relationship to the setting up or overcoming of these famous barriers of which I keep talking.

Although I have suggested that these breaks will occur naturally, you may have to control them, making sure that each chapter contains the right amount of material to advance the story. The chapters need not, incidentally, be of similar length, but it is probably wise to try to avoid a complete imbalance in this respect. If one of your chapters is excessively long, look for a place where it could be broken into two parts, which you may find more easily than you might think.

Another of John Braine's recommendations, but one for which I have much more regard, is that each chapter should finish with what he calls a 'hook' and I call a 'cliffhanger' (not that it matters which term you use). The dictionary defines a cliffhanger as a story in which suspense is the main element. I am not sure whether the compilers were aware that they were making a joke, because of course the term derives from the silent movies shown in serial form; at the end of one episode the heroine might be left literally hanging on a cliff, and you had to come back next week to find out how she got out of that predicament – 'suspense' is therefore an appropriate word in more than one way. The aim of a cliffhanger in a book is to leave the reader in suspense, wondering what will happen next, and that suspense is a spur to go on reading. So you end your chapter at the point when the hero has just told the heroine he is going to be sent to India, or as the mad elephant is charging towards the unprotected girl, or as the screw-down ceiling begins to descend.

What you may like to do next, immediately after the cliffhanger, if you can, is to switch the scene, move into a different aspect of the plot, or into a sub-plot, keeping the reader waiting for the resolution of the problem which formed the cliffhanger. This is to follow the well-known advice given by the Victorian novelist Charles Reade, who said, 'Make 'em laugh! Make 'em cry! But make 'em *wait!*' As has already been suggested, you should try to work out

just when you are going to give your readers various pieces of information, and some items, at least, you will certainly wish to withhold for a time. To give a very obvious example, your protagonist may be on trial, accused of some crime; you know, because you've worked out the plot, what the verdict will be; clearly you don't tell your readers in advance what it is, and indeed may do all you can to make them think that it is going to be the very opposite result.

Chronology

You will probably have worked out your plot in chronological order, beginning at the beginning and going on to the end and then stopping, which is entirely sensible. You may discover, however, that you can make the story more interesting by playing around with the time. For a start, if you are going to begin with a crisis point and a scene, you will not be able easily at that point to give your readers a lot of background information which they may need in order to understand the rest of the story. Perhaps the answer to this problem will be to use a flashback after the crisis scene, taking the readers back in time beyond the point where the book began to show them what happened earlier. You have the ability to play with the timing of various parts of your story in any way you choose, and sometimes you can do so with good effect, 'making 'em wait' just as Charles Reade advised.

The one essential, I think, unless it is your intention to confuse, is to make sure that you signpost the times, just as you will do the location, so that readers know when the scene is taking place as well as where. (There is, by the way, no reason why you shouldn't confuse your readers if you really want to – they may even enjoy it, provided that you don't overdo it, provided that the reader feels that the confusion is intentional on your part and not simply the result of your incompetence as a story-teller, and provided that you eventually sort things out.)

You can tell the reader when the various sections of your tale take place quite simply – there's no need to be devious about it. You can, for instance, use some such

phrase as 'next morning' or 'three years later' or 'the previous week', or you can give the date. A little more subtly you can indicate the timing by the use of internal evidence such as a reference to the protagonist's age, or to some background fact – for instance, snow will probably indicate that it is winter, the heroine's crinoline will tell us that we are in Victorian times, and mention of Mrs Thatcher as Prime Minister will almost certainly mean that the story, or that part of it, is taking place in the 1980s. Anything like this will allow readers to know that you have moved backwards or forwards in time, and to which point.

It is also worth remembering that, while the flashback is an extremely useful and quite acceptable device, like all story-telling tricks, it becomes both tired and obtrusive if you overdo it.

Putting It All Together

Once you have worked out the beginning, the middle and the end, and have made decisions about timing and variety and chronology and all the other matters covered in this chapter, it is time to put everything together and to take an overall look at it. Look for its shape. Look for a feeling of homogeneity. Look for a sense of completeness. And I hope too that you'll find in it one extra ingredient – an excitement which augurs well for the success of the book.

One major task remains, which is to put the plot down on paper before you start to write the book itself.

9 *Planning*

Preparing a Synopsis – the Pros and Cons
It will have become obvious to my readers by now, even if they have not heard me lecture on Creative Writing or have not read any of my books on the subject, that I believe in advance planning, and in the preparation of a synopsis.

I know that many well-known authors (John Fowles among them) never plan their books or write a synopsis in advance. I admire such authors, but I always have a suspicion that, even if they don't put anything down on paper, they do plan their books subconsciously, if in no other way. And at least they must surely have thought quite a lot about the sort of books they want to write, and about the characters, and, although they may not be sure of exactly how the book will end, they probably have in their minds some sort of goal, some sense that the moral order of which Brian Stableford writes will be preserved. If they have done none of that, if they simply sit down to write with no idea of what is going to flow from their fingers on to the page or the screen and still manage to produce a work of quality, then I not only admire them, I goggle.

If your inclination is to write your novel without planning it in advance, I am not sure why you have been reading this book. The very fact that you have taken it up would seem to suggest that you feel there is some point in thinking about plotting, rather than just leaving it all to chance and 'inspiration'. However, you are entitled to take any approach you like, and if you are a non-planner I just hope that you have found something worth your while in

the book. Perhaps you intend to tuck away in the back of your mind everything I have said which seems to you to make sense, and leave the subconscious to organize and plan and control as you go along. And that's fine. But for most of us, and especially for those who are starting out to write or who are trying to improve their writing skills, I believe a detailed synopsis is an invaluable tool.

Those tutors of Creative Writing and others who oppose the preparation of a synopsis usually advance three main arguments against it: a synopsis is a strait-jacket, they say, which stops you from developing ideas which emerge while you are writing; it not only prevents any feeling of spontaneity but will inevitably make your story seem stale; it precludes that marvellous moment when your characters come to life and start behaving in ways you had not expected, taking you into new adventures in your story.

It just ain't so. A strait-jacket? For heaven's sake, it's *your* synopsis, and there's no reason on earth why you shouldn't alter it at any time and at any point you want to. You can surprise yourself while you're writing (which is something to aim at, and a good thing to do because it will probably surprise your readers too), and if your new idea takes you in a new direction, that's fine. If you do make some change or other, my recommendation would be that you sit down and re-work the synopsis, to take account of the change and to make sure that the story as a whole is still what you want it to be.

'Ah,' they say, 'but if you have provided your publishers with a synopsis, they will be hopping mad if you depart from it, and indeed may refuse to publish the book.' Well, no publisher who has commissioned a novel (a fairly rare event, by the way) is likely to complain about a departure from the synopsis, provided that it is an improvement on the original plan and also that you have not suddenly, for instance, turned your tough thriller into a sentimental romance, or your historical novel about Henry V into a story of gay life in modern London. (If you are going to do something like that, you'd better let your publisher know before you get too far. Who knows? He or she might be delighted.)

As for your story lacking sparkle and spontaneity because it was planned in advance, the only reason why it should be so is because you're not a very good writer, and your writing would be just as dull even if you hadn't planned ahead. Further, I would defy any reader to work out from a 'spontaneity factor', if such a thing could be measured, whether this or that novel had been planned or not.

There is more than one way of adding sparkle to your writing. You can do it at the very beginning, by the invention and imagination that you bring to your planning. You can also do it at a very late stage: after you have completed your story and have already cut it to the bone, you go through once more aiming to take out another five per cent – a word or a sentence here, a paragraph there. Tight, economical writing always reads in a more spontaneous way than loose prose. But the most important thing to do comes in between those two extremes, while you are actually writing the book, and it is to *enjoy* both the story itself as you write it, and the effectiveness with which you put the words together, taking pride in your skill. If you have that feeling of enjoyment and pride, and even of excitement, I feel sure that your writing will appear to have spontaneity. Now, I know that authors differ widely in their methods and attitudes, and there may be some who find that having worked out a detailed synopsis the story has somehow lost its freshness for them and they cannot enjoy it so much when they come to put it down on paper. I find that hard to understand – if I invent a good story, I enjoy telling it to other people, and enjoy it each time I do so, whether orally or in the written word. But even if you lose that particular excitement, you can surely still take pleasure in your skill at writing it, and that delight of yours will add a measure of apparent spontaneity.

What I am saying, in fact, is that the *effect* of spontaneity does not come from spontaneous writing. On the contrary. Indeed, truly spontaneous writing is rarely admirable, because it lacks polish. This is not to say that odd passages – a sentence here, perhaps a whole sequence

there – which were written spontaneously cannot be effective, but the work which cannot be improved by being worked on is rare indeed.

Those who claim that planning destroys the sparkle are like those who advise against revision for the same reason. I always ask such people to consider the spontaneity of the great classic poems which are among the glories of our literature. Clearly they cannot have been planned, nor can they have been revised by their authors, because that would inevitably make the work sound stale, would it not? But take a look at the manuscripts of some of those great poems, and see how extensively they *have* been worked on. As Kathleen Raine says, 'Uncontrolled poetry has no character – and carefully worked-on poetry seems spontaneous and has style.'

And then this business of the character coming to life, taking over and steering your story off in a direction that you hadn't expected. It's certainly something that truly enlivens your book, and it's very exciting when it happens. But since I plan my novels in great detail, and a synopsis, so they say, stops any chance of your characters coming to life, how do I know that this is so? Because a synopsis does *not* prevent it from happening. Characters regularly come to life for me while I am working out the plot – they say things or do things in my mind which take me by surprise, and lead me towards unexpected developments. And they do it too during the actual writing, and since my synopsis is not a strait-jacket, and I *can* alter it in any way I wish, I am as delighted as any anti-planning tutor could wish when it happens.

There is, of course, one proviso: I do not want a Frankenstein's monster, who will take over the book so completely that it is no longer the book that I wanted to write, so I must keep control. When one of my characters comes to life, I look at my synopsis to see what effect it will have on the main story, and in particular whether I can use the development in this character to strengthen the novel; frequently I can do so, which is exciting; occasionally, however, I decide that this uncontrolled character is taking the novel in the wrong direction, and

then I go back over what I have so far written to the point when this person began to move away from the lines I had laid down for him or her, and I rewrite so that I am back with my original plan. And do I lose something as a result? Is there a loss of spontaneity? I honestly don't think so.

If you should find that despite all your efforts at control the character who has come to life persists in dominating the story and completely overshadows the person who is supposed to be the main character, it is highly likely that you began with the wrong protagonist, or one who was not strong enough. It's time to go back to the drawing-board, and to make up your mind whose story you want to write.

While on the subject of characters coming to life, I have a theory about Lady Catherine de Bourgh, star of *Pride and Prejudice*. I don't know to what extent, if at all, Jane Austen planned her books in advance, but I'd be willing to bet that when she started out on *Pride and Prejudice* Lady Catherine de Bourgh was intended to be the most minor of background characters, and that she then 'came to life'. Once she had done so, Jane Austen no doubt realized that she had created an original, a character who could not be left simply on the sidelines. She could have taken over and changed the course of the novel, but that would have been a mistake. An alternative was to find some other part in the story for her. And it was then (or so my theory goes) that Miss Austen decided that Lady Catherine would be Darcy's aunt, and that the relationship between Elizabeth and Darcy could be helpfully continued if the two should meet when Elizabeth was staying with her friend Charlotte and Darcy was visiting his aunt (what other reason could there have been for him to be at Rosings?).

The Benefits of Planning
Planning isn't easy. As Brian Stableford says in *The Way to Write Science Fiction*, 'the hardest work a writer has to do – far harder than thinking up ideas to use – is in shaping his story to display his idea to best advantage.' When you have done that hard work, it pays to put it down on paper in the form of a detailed synopsis.

The first benefit from so doing is that it is a discipline. Writing is a joy (don't ever believe an author who tells you that it is agony to write), but it is a craft which has to be learnt, and it is damned hard work. The joy comes naturally, without any effort on your part, but the learning of the craft and the hard work are matters for discipline. Like most self-imposed disciplines, that of working to a synopsis becomes a freedom.

Secondly, you will be able to tell more readily by planning than if you are simply trying to keep everything in your mind, whether you are writing the book you intended, or not. That sounds fairly absurd, but it is extremely easy, without a synopsis, to find yourself slipping from the romantic novel you wanted to write into a detective story, or from a thriller into a kind of travelogue. You will also find it much easier to tell whether you've got sufficient material for a novel or whether it's really just a long short story.

Thirdly, the preparation of a synopsis will allow you to record all your flashes of inspiration. By adding them to the synopsis you will not only ensure that they are in the right place, but will find it easier to see if some sort of preparation (a 'little cloud') is needed and if so where that is to go.

Fourthly, one of the best ways of telling whether your ideas are good ones is if you continue to find them interesting even when you know them backwards and have been working on them with great intensity as you fit them into your synopsis. And if you explore your ideas fully, you will avoid falling into the common trap of accepting the first 'inspiration' that comes to you in the belief that it cannot be bettered.

Fifthly, you will, I hope, be able to see the shape of your story, and the balance and variety within it, and to tell whether the major scenes are well spaced out, and the sub-plots sufficiently knitted into the main plot, and so on. Is the story going to sag part way through for lack of incident? If so, is there anything you can do about it? Have you started in the right place, and will the ending be satisfactory? If not, there is time for alterations. You

should also, if you have worked the synopsis out in sufficient detail, be able to tell whether the majority of things in it will work – whether the actions you have allocated to the people in your novel are all in character, whether the logistics and the timings are possible, whether the whole thing, in basics and in detail, is credible (it is almost inevitable that certain adjustments will have to be made as you go along, but with luck they will be minor). All this will require a certain detachment and a critical eye, and a great deal of time and thought. But don't skimp it. It is far better to devote a very considerable effort to getting it right at this stage, rather than having to tear it all up and start again when you discover that nothing works.

Sixthly, in general those who refuse to plan or to prepare synopses are more likely to suffer from writer's block. You are probably aware of the good advice given by Ernest Hemingway among others to break off your work at the end of the day in mid-sentence, because it will be so much easier to start again next morning. But I never mind if I finish the day at the end of a chapter, let alone at the end of a paragraph or a sentence, because I know from the synopsis exactly what comes next. So I don't suffer from writer's block (maybe I should say, 'touch wood'). I sometimes have problems at the planning stage, but as I have already said, planning is not easy, and you can't expect it to go completely smoothly. I don't really call that sort of difficulty a 'block' anyway. If all writers planned, I am sure we should not hear of writer's block nearly so often.

Finally (although if you give me time I may be able to think of some other reasons in favour of synopses), although it is increasingly difficult to get novels into print, publishers are not quite as insistent as they used to be on considering only completed typescripts. A synopsis and specimen chapters can be used to sell your novel. Moreover, if the book is accepted, the editor may have useful comments to make. However hard you have worked on the synopsis, you may have blind spots about this or that which the editor may be able to point out. He

or she might also ask for a major change of some kind. All this sort of thing will save you time and trouble later on.

How to Prepare the Synopsis

I am a word processor addict, and do all my writing on it – letters, articles, stories and books, whether they are novels or non-fiction. The word processor is marvellous for the facility it gives the writer to alter easily, to insert new sentences without making a mess of the thing, to move blocks of type from one place to another. But, despite all its advantages, when I prepare a synopsis, I do so in longhand. This is because, as I said at the beginning of this book, the construction of a plot is not something that works in a tidy logical order. The first thing after you've decided what sort of book you want to write may be the originating spark, and that should be followed by the main character(s) from which the ups and downs of the plot will develop, but from that point on, everything can be pretty chaotic as you get to know your characters better, and work out sub-plots, and fit them in here and there, bringing new influences to bear on the main story – not to mention the research you do for the backgrounds and the need to think about shape, and so on and so forth.

So I take a large pad and a pen and begin putting things down without bothering about the order, and certainly not going into great detail. John Hines, author of *The Way to Write Non-Fiction*, recommends using the 'sunburst' shape – in which you put your main idea in a circle in the middle of the page and all the developments which spring from that idea radiate on lines like sunrays coming out from that centre circle. I think the idea probably works better for non-fiction than fiction, but the value of the method is that it does not impose priorities on the various ideas in the way that setting them down on lines underneath one another seems to do.

To revert to my page – it has soon become pages, and they are a mess. Scribbled bits straggle all over the place, words are crammed into balloons, and arrows swoop about, taking a chunk from here to there, and of course crossings-out abound where the plot has gone off course,

or a character has come to life and gone in the wrong direction, or when I have reached a barrier in the story and can't find a way of overcoming it, and so have to go round it in some way. Just before the papers become totally indecipherable, I take a fresh sheet from the pad, and try to make sense of the chaos and put everything into some rough order. More amendments and new ideas are put down, and the process is repeated until I have got something approaching a plot summary, which begins at the beginning and works its way through to the end, and which is written in some detail.

At this point, since my novels usually cover a fairly long period and the characters are sometimes affected by outside events, I add in the dates at which various parts of the story take place. I find this helpful, not only so that I can work out all the timings, but also so that I know how old my characters are at various points in the novel – indeed, I will often add in 'X now 27, Y 25', or whatever it might be.

Having done this, I can now move to the word processor, and the next job is to turn the whole thing into a readable summary. It will then probably undergo several revisions before I produce a final version. This will be shown to my agent and publisher and will be a tool for me throughout the writing.

The amount of detail which goes into the final version varies from scene to scene – sometimes a crucial event in the novel will be described quite fully (giving some indication of how a peak in the plot will be made into a plateau, as it were), and occasionally I even include dialogue.

Two other important things happen in this process. One is that more and more often I *see* what I am writing about – I can visualize the scenes, I can hear the characters – it comes alive, and it's very exciting. And secondly the summary seems to fall naturally into paragraphs, and I have discovered that these paragraphs usually represent chapters.

How Long Should the Synopsis Be?

I am frequently asked how long a synopsis should be, and have to reply always with those unsatisfactory words, 'It all depends'. It depends firstly on the complexity of your

novel. If you are telling a long and complicated story with a great many characters, your synopsis will almost certainly be much longer than if the plot is a simple one. It also depends on just how much detail you feel it is useful to put in; if you look at the synopsis for *Mario's Vineyard* in Chapter 10, you will see that it amounts to close on 4,000 words, and includes a great many little details which might be regarded as superfluous. As I became more experienced, the synopses I prepared for my later novels became shorter – that for *The Silk Maker*, for instance, totalled just over 2,500 words, though the reduction in length was partly due to the fact that the story was not quite as involved as that of *Mario's Vineyard*.

I cannot give you a magic formula for the length of a synopsis, any more than I can in any other department of writing. All I can say is that the synopsis should be long enough to include every word which you will find helpful when you come to write the book. If that means 10,000 words, then that won't be too many, and if 500 words is adequate for you, then that won't be too few. The one caveat in respect of those figures is that if you are submitting a synopsis to a publisher, 10,000 words might be considered a bit long-winded, even for a lengthy book, and 500 a bit skimpy. So, although those lengths may be fine for you, perhaps you should consider aiming at somewhere between 1,000 and 4,000 words to send to a publisher or agent.

Yes or No
Whether or not you work in the same way as I have described is not really important, but I would recommend as strongly as possible, that you should prepare a synopsis for your book. And if you are one of those who don't like the idea, do ask yourself whether you are genuinely incapable of working out and using a synopsis, or whether it sounds a little too much like a boring postponement of the moment when you get on with what you really want to do – the writing itself. I can only say that I genuinely believe that, apart from its other virtues, a synopsis in the end will save you work and time.

10 Putting It Into Practice

If you want to write, and especially if your inclination is towards the novel, you can learn a great deal, I hope, from a book like this. But by far the best ways of learning are by practising your writing (and being critical of your own work and seeking to improve it), and by reading and analysing the work of published writers. In her excellent book, *Becoming a Writer*, Dorothea Brande suggests that you should read a book twice in quick succession. The first reading will be for pleasure, but the second time you will be trying to see just how the author did it, how the plot and the characters were manipulated, where the focus of attention is placed, how the subsidiary characters and sub-plots have been fitted in, the extent to which the story surprises you with its twists and turns, what part backgrounds and research play, how a variety of pace and mood has been added, whether there is a discernible shape to the story – you will be looking, in fact, for all the elements which have been discussed in this book. Moreover, you will be using your most critical eyes, trying to see where the author's failures lie, as well as his or her successes. What were the difficulties and to what extent were they satisfactorily overcome? You may find it helpful to write out a plot summary of the book in question – in fact it's a very good exercise for any would-be writer.

A summary of *this* book, step by step, might go something like this:

1 Decide what kind of novel you want to write.

2 Look for an originating spark.

3 Decide on your principal character(s). Get to know him, her or them in depth, and work out the aims and

ambitions of the character(s). Decide on the point of view that you are going to use.

4 Decide who the secondary characters are. Get to know them and work out how they and their aims and ambitions will affect the principal character(s). Remember the value of an antagonist.

5 Work out the sub-plots, making sure that they are interwoven with the main story and that they affect it.

6 Decide on your background, whether passive or active, and what part it will play in the story.

7 Put the story together, working out the barriers that will frustrate the principal character(s) and how they will be overcome. Give your plot plenty of twists and turns, but try to avoid any which are predictable or which do not play fair with the reader. Look for the shape of your novel, and make sure that it will have plenty of variety.

8 Write the synopsis (unless you really can't work that way).

I must remind you yet again that it is virtually impossible to see precisely in what order a plot is constructed. The first three steps listed above are likely to be the beginning of the book, but after that it may be all confusion. Ideas for different bits of the story flow in, subsidiary characters and their exploits jump into your mind, scenes materialize, and so on and so forth, and many of these factors will have a major effect on your central character, and that in turn will alter the story. And all this great jumble of thoughts has to be sorted out (which also includes getting rid of any extraneous material), and it may not be possible to do so satisfactorily before you get to steps 7 and 8. Much of plotting really is a 'which came first, the chicken or the egg?' kind of process.

In order to move from theory to examples of plotting in practice – I want now to take one of my own novels, *Mario's Vineyard*, to discuss how it began, how the plot developed, to show the synopsis that was prepared, and then to explain various points, including what went wrong and why. It may appear vain of me to use my own book in this way, but I pick it not only because I can truly speak with authority on its genesis and development, but

also because it will be possible for me to show you how the written work differed from the synopsis, and to point out the mistakes that I made.

Mario's Vineyard

The Beginnings

This novel originated when my publisher visited a vineyard in the Sonoma Valley in California, and came away with a brochure which described how the present owner's grandfather had come from Tuscany to California in the 1890s, had bought the vineyard, at that time in a run-down condition, and had built it up to a prosperous state, which his descendants had maintained. 'There,' said my publisher, 'is a theme for your novel.'

I should at this point make it clear that I am aware how lucky I was to know a publisher who was prepared to entrust an idea of this kind to me. It helped me to a start which many would-be novelists will rightly envy. I would say, however, as firmly as possible, that it is not essential to know a publisher or an agent personally if you want to get published. It is not how most published authors begin – they just write good books, and the quality of their writing opens the door for them. In any case, being given the idea by a publisher did not mean instant acceptance and success – I still had to write a more-than-adequate story. That meant putting together a plot which needed to be as interesting, complex and original as I could manage, based on characters which I would try to make real to the reader, and with a background which would have to be researched with some care. A publisher's interest, even if it goes as far as suggesting a novel's theme, guarantees nothing – you still have to get it right.

You might say, then, that I was given the originating spark – the idea of an Italian going to California and running a successful vineyard there. But you will remember my suggestion of an earlier element in a story's origination – the author's desire to write a particular kind of novel. I had in mind an entertainment rather than a literary work – a long novel, covering some fifty years or so, involving many

characters and set mainly in the nineteenth century. It would not be a family saga, exactly, although the protagonist's family would have an important part to play, and the main theme would be the hero's rise from poverty to affluence. Fortunately this was all acceptable to my publisher.

Who Was the Central Character to be?

I began to see my protagonist almost immediately. He was young, handsome, ambitious, enthusiastic, sparkling with life, strong enough to remain unbowed, however bloodied he might be, by the adversities he would encounter, and of course he had an instinctive understanding of viniculture. He was quickly named as 'Mario Gilardone' – 'Mario' because I liked the name and it seemed to me to have the right vibrations and to fit the picture of the man in my mind, and 'Gilardone' because it was the name of some Italian forebears in my own family.

The Italian in the brochure my publisher had been given came from Tuscany and went to the Sonoma Valley, north of San Francisco, so, just to be different, Mario would come from Lombardy and go to the Napa Valley, which runs almost parallel to Sonoma. But if those locales were chosen simply to avoid echoing the original of the story too closely, the next change was a much more important one: the young man in the brochure had gone to California with sufficient cash to buy a vineyard and to restore its fortunes; there was little drama in that, and my Mario would go to the Napa Valley alone and penniless – a major barrier for him to overcome in the goal that I gave him of owning a highly successful Californian vineyard.

The Viewpoint

Although I was already identifying with Mario, I did not see this as a first-person narrative. Nor, since everything was going to centre on Mario, did I consider the God's-eye view. But while ninety per cent or more of the narrative would be in the third person through Mario's eyes, I was already planning the occasional excursion into the minds of other characters.

Who Were the Other Main Characters to be?

Mario would naturally have a family. His father, I decided, would be a very dominant man, and although he would have great affection for Mario, there would be considerable friction between them, and this would be one of the motives which would drive him to leave home. His mother would be gentler, and something of a restraining influence on his father.

I decided to restrict Mario to one brother and two sisters. The brother would be Enrico, older than Mario (and therefore heir to his father's vineyard – another reason for Mario wanting to branch out on his own), a dull, stolid chap in contrast to the ebullient Mario. The sisters would be Giulia and Francesca. I was planning a major part in the story for Giulia, who would follow Mario to California. On the other hand, I did not have much in mind for Francesca (and if I rewrote the book would probably eliminate her).

Mario would need to marry and produce a family, so I gave him a girlfriend, Teresa Pella. Her brother Paolo would be Mario's best friend and confidant. Before long I had also decided that Mario and Teresa would produce four children – three boys and a girl – and had worked out what sort of people they would be and how they would affect Mario's story.

Since the family could not live in isolation in California, I invented their neighbours and friends, the Corsinis, an Italian family (which would make the friendship a natural development), consisting of Salvatore and Agnese, and their children, Lorenzo and Caterina. I needed the Corsinis for many reasons connected not only with friendship, but with Mario's business, too.

As the story grew in my mind, other subsidiary but important characters began to materialize, some emerging because, even with Paolo's help, Mario would not have been able to cope on his own with all the work in the vineyard and winery. The main helpers were Absalom, the black, and the Jewish couple, Mordecai and Sarah Goldberg. There was also the Corsini cousin, Elena, whose arrival was to blight the romance between Giulia and

Lorenzo Corsini.

Further developments in the construction of the plot came about because I did not want the less important characters who appeared early in the story to disappear totally thereafter. This led me, for instance, to plan to include the death of Mario's father, and Mario's return to Italy. But this needed to be tied into the plot more tightly, so that the whole episode had a major effect on Mario. I had decided that poor Teresa would not survive the birth of their fourth child, but I wanted Mario to marry again, and I now planned that he would meet his second wife, Bianca, while in Italy for his father's funeral.

What About Barriers?

As well as allowing Mario to arrive in California without money and with the additional handicap of not speaking English, I wanted an antagonist, who would provide ongoing opposition to Mario and his ambitions, and this character was to be a Frenchman, François Duchêne.

Having made him penniless and given him an implacable enemy in Duchêne, how was poor Mario ever to succeed? I realized that he would need help in climbing these two barriers, and this led to the invention of Emily King, the wealthy and attractive San Franciscan. But how could I contrive a first meeting between Emily and Mario which would develop into a deep relationship and bring about her essential patronage?

The more I thought about it, the more problems I found for Mario. Through Emily he would become manager of a vineyard, but that would not satisfy his main ambition of being the owner. And if he had set his heart on owning one particular vineyard, that would make it even more difficult for him to achieve his goal. Then there were his children, whom I did not want to be merely background figures – what would I do with them? I spent quite a lot of time asking myself 'what if ...?'

The Time-span

I intended to take Mario up to his sixtieth birthday (cause for a celebration at which it would be clear that he had

achieved just about all of his lifelong ambitions). I did not want to follow him beyond that age, because that would have meant moving the focus of attention from Mario to his children, and although they were to play an important part in the story, the novel was centred on Mario, rather than on the family as a whole. To end with his death would have been too downbeat. And finally, having settled on the date when the story would begin (as explained on the next page) when Mario would be twenty-two, if I finished the story when he was sixty, I could do so before the entry of the United States into World War I, an event which I could not have ignored, but the effects of which on Mario and his family I did not wish to explore.

Sub-plots
There were to be no sub-plots of major importance, unless one were to consider the whole of Mario's family relationships as a sub-plot in contrast to his occupation and ambitions as the owner of a successful vineyard. What sub-plots there were would come from Giulia and Lorenzo Corsini (a romance which demanded the invention of Lorenzo's cousin Elena, who would come between them), from Paolo and Caterina, and from Mario's children and Paolo's. The children all had aims and ambitions of their own, which would have an effect on Mario.

The Background and Research
The physical backgrounds – the Valtellina and the Napa Valley – were of what I call the passive variety. Nevertheless, they were of some importance, and I planned and later carried out expeditions to Italy and California. I like always to see the area where any of my stories is set, and if they take place in the nineteenth century, I find it quite possible mentally to remove all the high-rise buildings and television aerials in order to get an idea of what it was like a hundred years or more ago.

The background of the wine business, on the other hand, was to be an extremely active part of the book. There would be descriptions of how vines were grown,

how the grapes are gathered, and of all the processes which are part of the production of wine. Since I knew nothing about viniculture and the making of wine, I would have to do a great deal of research. I always turn first to the *Encyclopaedia Britannica*. In the entry on the diseases of vines, I learned about phylloxera, the insect-scourge which crossed the Atlantic in the middle of the nineteenth century and from 1865 onwards destroyed vineyards throughout Europe. The Italian authorities took precautions against the disease and the Alps formed something of a barrier, but by 1879 the phylloxera flies had reached Italy. This was an extremely exciting discovery, for if the Gilardone vineyard was afflicted with phylloxera it would give me Mario's principal motive in going to California, where the vines were largely immune (though phylloxera did afflict American vineyards in 1890 – another problem for Mario when he was actually in California).

The Heart and the Head

During the somewhat haphazard process of constructing a plot it is essential to exercise control – to select and manipulate and shape your material. That does not mean that everything is done from a distance, as it were, observing the story dispassionately. Much of my plotting came deeply from the heart, as it must always do if a book is to be successful. I was soon absorbed by Mario – I could see him and hear him, and I knew all about him – and I desperately wanted him to succeed and be happy. He was part of me, and I was most of him. I felt a similar reality, if to a lesser extent, in some of the supporting characters. I could also see many events in the story – there were scenes in front of my eyes, just waiting to be written down. And all this had come from ... where? The subconscious, perhaps, or from the heart. It was not calculated, or in any way remote.

Other things evolved with conscious, careful deliberation. One example is the use of phylloxera's arrival in Italy as a prime reason for Mario's emigration. Another is the solution I found to a problem mentioned only briefly

in the synopsis – the killing off by me of Mario's friend, Salvatore Corsini; I had already got rid of some characters by means of various diseases and did not want to make him the victim of yet another 'flu epidemic; then I remembered that the date was 1906, so I invented a logical reason within the plot for sending him to San Francisco on April 17th in that year, the day before the great earthquake and the fire; not only did Salvatore perish, as he had to for the sake of the story, but I had a valid reason to describe (briefly, and trying not to let my research show) the city as it was after the disaster.

Even more cynical manipulations resulted in the introduction of Absalom and the Goldbergs and the nationality of the antagonist. Absalom was, I'm afraid, a 'token black', while the Goldbergs, in a book which it was hoped would sell to an American publisher, were equally, alas, 'token' Jews. As for 'Francois Duchêne', I made him a Frenchman because although I had some hopes of selling Italian, German and Dutch translation rights, I did not expect a novel about an Italian making Californian wine to have any interest for a French publisher. Ironically, the book did not sell in America, or in Italy, Holland or Germany. It did, however, attract a substantial offer from a French publisher, who, after the contract had been signed, diffidently asked whether it would be possible to change the nationality of the antagonist. I agreed and in the French edition François Duchêne became 'Friedrich Eichenbaum'.

The Synopsis
Here then is the final synopsis for *Mario's Vineyard* (or as it was called at that stage, *The Wine of San Cristoforo*), together with notes on specific points.

The Wine of San Cristoforo[1]

PART ONE

It is the autumn of 1878, and in Montefiore, a small town in the Valtellina in Lombardy the people are celebrating

the harvest of the grapes. There is music and dancing in the streets, and everyone is drinking wine. The girls are in their best finery, and they are all beautiful, just as the young men are all handsome – none more so than twenty-two-year-old Mario Gilardone. All the girls want to flirt with him. Not only is he strong, tall and handsome, but he is also the son of Benito Gilardone, owner of one of the finest vineyards in Lombardy, and therefore a catch for any girl. But tonight Mario has eyes only for Teresa, sister of his friend, Paolo Pella. She is seventeen, sweet and shy, and has enough of a head on her shoulders to limit Mario to the fervent squeezing of her trim waist and a passionate kiss or two.

The older people content themselves with watching. Among them are Benito and his wife Anna. As it grows late, Benito becomes increasingly angry at Mario. He should have been home hours ago, like his older brother Enrico. The boy is undisciplined and wild, and has been with Teresa and Paolo Pella, whose father is Benito's sworn enemy.[2] When Mario at last arrives home, Benito lashes at him with his tongue, reminding him that there is much work to be done tomorrow.

Briefly (because it will be described in detail later) we see the work – next day and during the days and weeks and months thereafter.

The Spring of 1879 comes and the leaves appear on the vines. But it is soon apparent that there is something wrong. Phylloxera, which has previously ravaged the vineyards of France, has, despite all efforts to prevent it, reached Italy. It is utter disaster for the Gilardones, their neighbours and the town.[3]

A family conference takes place. Mario has been talking to his friend Paolo, about the wine industry in California, and Paolo, who is something of a hothead, has declared that he will leave Italy and go to America. Mario proposes enthusiastically that the family should also emigrate to the West Coast, but Benito dismisses the idea. He will buy American stock, which is immune to phylloxera, and graft on to it the local vines. There have been scourges before – the mildew, and the year of the torrential rain which

ruined the crop – and they must simply build again. Mario presses his argument, and finds himself alone – the whole family is against him. He swears he will go alone, but Benito reminds him that he has no money.

Later Anna persuades her husband to let Mario go. She recognizes that there will always be conflict between them and that Mario's ambitions will drive him from home sooner or later. Benito grudgingly gives Mario his blessing and money for his fare to New York. There, Mario declares, he will work until he has enough saved to get to California, where he will find a job in the vineyards.

Signor Pella dies, which means that Paolo can no longer leave Montefiore. Mario decides that he will go on his own.[4] He sees Teresa, tells her he loves her and that when he is owner of a vineyard in California he will send for her and they will be married. Teresa says goodbye to him, knowing she will not see him again.

Arriving in Genoa, Mario decides to work his passage to America if he can, and manages to get a job as a dishwasher on a liner. He has a teach-yourself-English book and studies hard during the voyage. One of his fellow kitchen hands is English, and helps him. This man, Eddie Taylor, advises him to take the train from New York to the West, and he decides to do so, since he still has some of his father's money left.[5]

Having got through Immigration, he catches the train. On the journey he falls in with card sharps, but recognizes them for what they are and leaves the game quickly while they are still allowing him to win. They try to beat him up, but he defends himself successfully.[6]

PART TWO

Arriving in San Francisco in June 1879, Mario travels north to the Napa Valley. He stops in a small town, Cinnabar,[7] and finds cheap lodgings. That evening, exploring the town, he comes across a man and a girl struggling in a dark alley. She is a local whore, while he is François Duchêne, a big middle-aged man. Mario rescues the girl,

beating up Duchêne. The girl offers Mario her services – free.

The next day Mario tramps around, looking at the local vineyards. One in particular appeals to him – that, he decides is the one he will one day own, and ownership of it later becomes an obsession. He asks for work there and is sent to the patron, who is Duchêne. He is thrown off. He limps to another vineyard and is taken on as a field hand, but the next day he is fired, and no other vineyard will hire him – evidently Duchêne has effectively spread the word that he is a troublemaker.

He takes a job in San Francisco as a labourer, making roads. It is hard work and poorly paid, so that he can save only a dollar or two a week. He takes an evening job as a porter in a low-class hotel, hoping he will be able to eat there, but food is not included in the wages, so he exists on a near-starvation diet, obsessed by the need to save. Again the wage is small, but there are occasional tips, including one, which he remembers because it is more generous than the others, from Emily King. She is the daughter of a local millionaire, John King. She is beautiful, spoilt and promiscuous. She has come to the hotel with a young man, intending to hire a room for an hour or two, but the hotel is too sleazy for her, and she walks out.

One evening in January 1881, when Mario is walking to the hotel, he faints from cold, exhaustion and lack of food. He is outside the King mansion. Emily sees him, takes him in, and when he is restored to health offers him a job as a gardener. Occasionally she invites him into her bed. His wages are good and his savings mount, but it is obviously going to be a very long time before he will be able to buy even the smallest vineyard. Emily's father, a widower, takes to Mario, who asks his advice on getting a bank loan. This leads to Mario explaining his history and ambitions, and when King checks his knowledge of wine, he is very impressed.[8] Mario is now 25.

After Mario has been with the Kings for a year, a small vineyard called San Cristobal comes on to the market. Emily persuades her father to bid for it, with the idea of letting Mario run it. At the auction the opposition comes

from Duchêne, whose land adjoins San Cristoal. He outbids King, but at the last minute Emily makes the winning bid.[9]

Mario first action is to write to Teresa, sending her the money for her to travel to California. When he moves into San Cristobal after Easter, disappointed not to have heard from Teresa, Mario finds there is much work to do, for the vineyard has been neglected in recent years. There are two field hands, both old men, who soon leave, offered far more by Duchêne than Mario can afford to pay them. Emily visits the vineyard and she and Mario make love among the vines under the open skies. Emily asks why he has no helpers and when she hears the reason says that her father can put pressure on Duchêne. Mario refuses – he must be his own man. As Emily is leaving she remembers that she came to give Mario a letter. It is from Teresa, saying that she is coming to him. When Mario reads it, he tells Emily that their affair is over. She is amused.

Mario tries to hire hands. No one with any experience will come to work for him. Then he meets Absalom, a black who after the Civil War has come to the West. He has no knowledge of vines, but has worked in the cotton fields. Mario takes him on and they work well together. Duchêne continues his harassment and one evening in town Absalom is attacked. Mario wants to confront Duchêne, but Absalom persuades him that the time is not yet ripe. Better to save their energies for the vineyard.

In June 1882, Teresa arrives. To Mario's astonishment and delight, she is accompanied by his sister Giulia,[10] and her brother Paolo. Giulia has come to escape from problems at home, while Paolo has come to work with Mario in the vineyard. Everyone is delighted, except Absalom, who sees himself displaced as Mario's chief helper. In particular he dislikes Giulia, who makes no secret of her feelings about blacks. The wedding of Mario and Teresa is swiftly arranged and held.

By July, with all this help, the vineyard is showing signs of improvement, though the earlier neglect can hardly mean a good crop. Several neighbours come to see

whether Duchêne's calumnies about Mario are true, and go away impressed. One family from a nearby vineyard becomes friendly – they are Salvatore and Agnese Corsini, both in their late forties, and their children, twenty-year-old Lorenzo and twenty-two-year-old Caterina. It is soon evident that Lorenzo and Giulia are in love, and Caterina dotes on Paolo. Paolo, however, has no intention of settling down yet.

All is going well in the vineyard, but just before the harvest a great quantity of the vines is damaged by men in Duchêne's pay. Paolo and Absalom go in search of them and Paolo kills one of them. At the subsequent trial Absalom's evidence succeeds in proving that the killing was in self-defence and Paolo is acquitted. Was Absalom's evidence true? Only he and Paolo know, and they won't say. King puts pressure on Duchêne to stop harassing Mario, and it seems that there is peace between them. Mario is not sure about it.

Just at the time of the sabotage, Teresa tells Mario that she is pregnant. She is bitterly disappointed that he reacts very casually to the news, but later realizes that he was worried at the time and that he is in fact very happy about the baby.

In January 1883 Mario and all his family are rebuilding the winery. Teresa tries to lift something very heavy, which causes her to have a miscarriage. Mario is very disheartened and wants to quit, but Teresa won't let him do so.

Some weeks later Giulia and Lorenzo announce their engagement. Then a distant relative of the Corsinis comes from Chicago to visit them. Elena is beautiful and sophisticated, and although Lorenzo appears to be indifferent to her, it is suddenly announced that he and Elena have eloped. Giulia becomes desperately ill from the shock, and though she eventually recovers, it is some years before she finds life worth living again.[11]

Meanwhile, John King, terminally ill, has decided to sell San Cristobal. Mario is devastated, but with help from Emily he and Salvatore Corsini jointly buy the vineyard. It is decided to Italianize the name and call it San Cristoforo.

By May, Teresa is pregnant again. So, Caterina tells Paolo, is she. They are hastily married, but in a few weeks'

time Paolo realizes that Caterina has tricked him. A violent quarrel leads to equally violent love-making, and by August Caterina discovers that she is truly with child.

The grape harvest in October is a fine one and Mario is hopeful that in two years' time when the wine is ready for sale he will make a lot of money and be able to start repaying Emily King. At this point there will be a detailed description of the wine-making process. Mario is now 27.

The years pass by. In December Teresa's first child Benito is born, and in March of 1884 Caterina also has a son Ricardo. That year Mario clears a tree-covered piece of land and plants more vines, so as to increase future output. Teresa and Caterina have more children. Teresa bears Giovanni in February 1886, and Margherita in June 1887, while Caterina has Bettina in March 1885 and Vincenzo, born a hunchback, in March 1888. In 1889 Teresa is pregnant again and a third son, Carlo, is born in October, but Teresa dies in childbirth. Mario is heartbroken, but after some months resumes his affair with Emily. He manages to pay off his debt to her.

It is Spring 1890 and the vines are sprouting once more – but something is amiss. Phylloxera has come to California. To make matters worse for Mario, Emily announces that she is going to be married and is moving to Philadelphia. Strangely, the pests have not come to Duchêne's vineyard, which is immune. Many local growers come for new stock, and he sells to them all – except to Mario.[12] Scouring California, Mario and the Corsinis eventually procure new stock and start again. As Teresa had told Mario, you cannot quit just because a few things go wrong. Mario is now 33.

PART THREE

It is 1905, fifteen years later.[13] Mario is now 49. Paolo and Caterina have left San Cristoforo and are now helping to run the Corsini vineyard. Mario continues at San Cristoforo, helped by his children, Absalom, and Mordecai and Sarah Goldberg, who have been with him for five years or so. The Goldbergs have a fourteen-year-old

daughter, Esther. Aunt Giulia, who found her purpose in life when Teresa died, becoming a mother to Mario's children, is still there, fat and happy, running the house, cooking endless supplies of pasta, and not only reconciled to her spinsterhood but also to Absalom, with whom she has a bantering, almost affectionate relationship. The vineyard has prospered, but many of the processes used, and certainly the marketing arrangements, are old-fashioned and inefficient, though co-operation between the Corsinis and San Cristoforo helps both the vineyards to be more profitable.

Mario's eldest son Ben, a difficult boy, is having a passionate affair with his cousin Bettina, daughter of Paolo and Caterina. Emily returns to California after a divorce, and comes back into Mario's life. They meet regularly once a week. The rest of the family regard their relationship tolerantly as his little foible.

A telegram arrives in the Spring from Italy with the news that Mario's father is seriously ill. Mario and Giulia journey back home, arriving just in time to see Benito, who, before he dies, tries to persuade Mario to stay in Montefiore. To make the old man happy, Mario agrees, but he is already itching to get back to San Cristoforo, and anyway Enrico is there to look after his mother.

At the funeral, Mario meets Bianca, a widow and friend of the family. He is captivated by her, unable to see that though she may share something of Teresa's looks, she has none of her character. Mario lingers on in Montefiore and despite Giulia's opposition, proposes to Bianca and marries her just before leaving to return to the States. The honeymoon on the journey back is idyllic for Mario, who does not seem to notice Bianca's extravagance.

When they arrive back at San Cristoforo that autumn, everything is in good shape, except that Mario's eldest son, Ben, has left home. He has never got on with his father and hates wine-growing, and has taken advantage of Mario's absence to go off to the bright lights and glamour of New York. Mario is very upset, but gets little sympathy from Bianca, and begins to wonder for the first time whether he made a mistake in marrying her. It soon

becomes more apparent that the marriage was disastrous. Bianca tries to change everything, and the rest of the family – especially Giulia and Absalom – is united in hating her. Emily finds the situation amusing.

The other children, Giovanni, Margherita and Carlo, are now nineteen, eighteen and sixteen. Giovanni is quite close to his father, but he too has no aptitude for viniculture. Margherita is a tomboy, and will outwork any man in the vineyard.[14] Bianca is horrified by her hoydenish ways, especially as Margherita shows no sign of looking, as any self-respecting girl of her age should, for a husband. Carlo is delicate, a quiet boy, whose lack of physical strength disappoints his father. Unknown to anyone but Giulia, he has been studying, and he now tells Mario that he wants to be a doctor and has acquired sufficient qualifications to be accepted for training. Reluctantly Mario agrees.

Bettina discovers she is pregnant – the result of her last love-making with Ben. No one knows what to do, since they don't know how to find Ben. Mario goes to New York and finds Ben, but fails to persuade him to return. A violent epidemic hits the Napa valley. Bettina is one of the victims and dies, and so does Léon, Duchêne's son and heir.[15] The Gilardones and Pellas are at last reconciled with Duchêne as they mourn. The reconciliation leads to a meeting between Margherita and Pierre, Duchêne's young grandson.

The tension between Mario and Bianca increases, and after some twelve months of married life and following a tremendous quarrel, Bianca leaves to go back to Italy, taking with her a generous settlement in the shape of the larger part of Mario's savings. Everyone is very relieved, but very soon after she has gone, Mario suffers a stroke. It is obvious that he will never again be fully active. He resumes his relationship with Emily, but now it is companionship rather than sex that they seek.

Salvatore dies, and although he does not own it all, Mario is now the undisputed patrone of San Cristoforo. He begins to worry about the succession. Ben has gone, Giovanni has no interest in growing vines, and Carlo is

going to be a doctor, so what can he do? It takes him a long time to realize that Margherita's sex is no handicap to her, and gradually he allows her to take over. She persuades him that the winery must be modernized, even if this takes the last penny of his savings, and that something must be done to improve the marketing of the wine. That is not her scene – she is above all a grower – but Giovanni becomes sales manager for San Cristoforo and is very successful. Mordecai, it transpires, has a gift for machinery and takes charge of the new wine-making equipment which Margherita buys. Additionally she experiments with new varieties of grape.

Paolo watches what is happening with great interest. He has no worries about his succession – Ricardo, his lumpish older son, will clearly take over in due course – though he and Caterina are very concerned about Vincenzo, the hunchback, who seems to have no interest in anything, and spends most of his time whittling wood. Paolo suggests to Mario that Ricardo and Margherita should marry – they are first cousins, but the important thing is that eventually their two vineyards should be united. At this time Ricardo is twenty-four and Margherita twenty-one. Mario likes the idea, but Margherita rejects it out of hand, saying that she will not marry a womanizer like Ricardo, who takes after his father. Caterina is entirely used to Paolo's roving ways and tries to persuade Margherita that an unfaithful husband is not necessarily a bad one, but Margherita says she has no intention of marrying yet anyway, and the marriage is not necessary because the two vineyards already work satisfactorily together.

San Cristoforo continues to thrive. At long last in 1909 the Gilardone wines win an annual award which has previously always gone to Duchêne. But Giovanni has not yet achieved his great ambition of seeing San Cristoforo wine served at a White House State dinner.

Vincenzo's talent now finds an outlet and he begins to carve the San Cristoforo wine barrels with exquisite designs. A local newspaper reporter discovers this, writes it up and the vineyard becomes a tourist attraction. Sales rocket.

The years go by. It is now 1911. Mario is 55. Despite the religious problems which cause some opposition from both families, Giovanni marries Esther Goldberg. Ricardo also marries, but Margherita remains wedded only to the vineyard, continually improving the stock, increasing the output and trying new strains of vine. Carlo comes on a visit to San Cristoforo, bringing with him a fellow-doctor friend, Tom Johnson. Tom and Margherita fall in love. Mario is both pleased that Margherita has a beau and worried that she may leave to become a doctor's wife. But when Tom asks her to marry him, she refuses. She has another plan.

Time passes. By 1915 Duchêne is growing old and, since the death of his son, his hopes have been centred on his grandson and heir, Pierre. Margherita has befriended the boy, eight years younger than she is, and now that he is twenty she sets out to capture him. He is charming, but not a very strong character, and the conquest is not too difficult. Margherita marries him, and waits for Duchêne, now in his seventies, to die. Although it begins as a marriage of convenience, love gradually blossoms.

The following year, 1916, as a result of a direct approach by Esther to the First Lady, Giovanni achieves his ambition and San Cristoforo wine is served in the White House. This is Giovanni's great gift to Mario. Duchêne dies, and his vineyard at last belongs to the Gilardones. This is Margherita's great gift to Mario. He is delighted of course – and does not tell her that long ago he had lost all envy for Duchêne's vineyard, loving San Cristoforo too much. Of more importance to him is his belief, as yet unconfirmed to him by Margherita, that she is pregnant. The San Cristoforo dynasty will continue. Perhaps if it is a boy they will name him Mario.[16]

Notes

[1] When the book was completed, my publisher decided that he did not like *The Wine of San Cristoforo* as a title. Over quite a long period alternatives were suggested and discarded. *Mario's Vineyard* was the suggestion of the paperback publisher who had bought the softcover rights.

I was not enormously enamoured of it, but I doubt whether the book would have sold any more copies (or any fewer, for that matter) if it had been called *The Wine of San Cristoforo*, which is the title I still prefer.

2 This Romeo and Juliet theme is of minor significance only, but it provides another problem for Mario, and an additional reason for his antagonism towards his father.

3 If I were rewriting the book, it is at this point that I should begin. The preliminary material in the published version was not, I think, too slow-moving, but the discovery of phylloxera is the real moment of crisis.

4 My first thought was to allow Mario and Paolo to travel together to California. It would have been useful for Mario to have a friend who would support him in his difficulties, who would also be a confidant with whom he could share his hopes and his fears in those early days. However, it was much more dramatic for Mario to go on his own, and it showed the strength of his determination (or stubbornness). It also gave him yet another barrier to overcome – that of being alone in a strange country.

5 This was one of several parts of the original synopsis which did not work. When I came to write this section it seemed to me extremely unlikely that Mario would be taken on as part of the crew of a liner without some outside help, and it would also have been too easy for him. What if, I thought, Eddie Taylor were to provide that help? But he would want some kind of payment, and Mario had no money to spare. So I made Eddie gay, and Mario was forced, because he had no other way of getting to America and because Eddie had taken possession of his passport, to accept Eddie's sexual demands. Their relationship also led to a scene of some violence when the liner reached New York and Mario had to escape from Eddie's clutches.

6 Because of Mario's problems with Eddie, and the physical violence when he left the ship, I decided to dispense with the card sharps.

7 The Napa Valley is real, but Cinnabar is an invented town. In the same way, you will not find a town called Montefiore in the Valtellina.

8 The sections in the synopsis concerned with Mario's first

encounter with Emily King and his employment in the King establishment were, I realized, quite absurd. Firstly, Emily might be promiscuous, but she would never have taken one of her lovers to a cheap hotel – or even an expensive one. Secondly, if Mario had fainted on her doorstep, Emily would certainly have looked the other way (not because she was lacking in compassion, but because in 1881 a wealthy young woman would not feel any responsibility for a poor immigrant worker). I therefore had to find another way of getting Mario into Emily's employment, and decided that he would simply answer an advertisement for a gardener. Once he did not have to faint outside Emily's house, I was also able to relieve him of having to take the hotel job. Another change concerned his relationship with John King, who would hardly have treated him with the kind of friendliness that the synopsis suggests. These problems were all of my own making. If I had thought out the background and especially Emily's character with more care, I should not have put such nonsenses into the synopsis. As the writing of the book proceeded, other similar changes had to be made, but none were quite as shameful examples of poor plotting as these.

[9] Although the auction and Emily's last-minute winning bid make a dramatic scene, the episode is one example of a major flaw in the novel, which is that Mario owes too much of his success to Emily's generosity, rather than to his own unaided efforts. Admittedly, she is generous because he is a good lover, but that is insufficient justification. If I were rewriting the novel, I would try to change this aspect as much as possible. For instance, I would allow Mario, in the heat of the moment, to make the winning bid for the San Cristobal vineyard – to the temporary fury of both Emily and John King. It would still be King money, but at least Mario would have made the purchase himself. I would not eliminate every episode in which Mario gained from other people's actions, but I would try to give him more responsibility for his own success.

[10] It is of course pretty improbable that her parents would ever have allowed Giulia to come to California, but I needed her there to bring up Mario's children after Teresa's death.

[11] Giulia cannot be allowed to marry Lorenzo, because of my plans for her future. So Lorenzo had to be stolen away from her by Elena.

[12] Poor Mario! One problem, or barrier, or disaster must follow another.

[13] The events of these fifteen years are not totally ignored, but since they include little drama, they are covered in the book in flashback as quickly as possible, so that we can proceed with the next part of the story.

[14] Another improbability. Margherita, although perhaps she would have been recruited to work in the vineyard at the busiest times, would almost certainly not have been allowed to do anything but unskilled work. Instead, she would have been expected to help her Aunt Giulia and learn the skills of housewifery in preparation for her eventual marriage. Nevertheless, I wanted her in due course to take over the running of the vineyard from Mario, partly because it seemed right, and partly because I thought that readers would like it. So she had to be a tomboy, and she had also to have inherited the streak of determination which had driven Mario and which would later in the story allow her to think of Pierre Duchêne as a husband before coming to love him. One always has to be careful not merely to be true to the character, but also to keep as far as possible in period, hoping at the same time to please modern readers.

[15] At one time I had planned that Margherita would marry Léon. But Léon was a lot older than she was, and would probably not have been so easy for her to manipulate in the way that I intended. So I decided that Léon's son, Pierre, would eventually become her husband, and that not only suited my plans, but gave an extra little twist to the story.

[16] This synopsis is considerably more than 3,500 words in length. That may not be considered excessive for a novel which extended to over 200,000 words. However, readers will have no doubt noticed that the synopsis often includes details which are not really necessary, whereas some major developments in the story are glossed over very quickly. If I were rewriting it now, it would probably

not run to much more than 3,000 words, and the balance within it would be less unsteady.

A Final Word

I hope that this synopsis, and particularly the comments preceding it and the notes which followed it, will have been helpful in showing how I put my own precepts, as laid down in this book, into practice – and where I failed to do so. I think they are good precepts, and if I had followed them more carefully, I should not have had so many occasions to point out where things went wrong. That is one of the reasons why I commend the approach explained in this book to all would-be novelists.

However, I am always conscious of the fact that there really are no rules in writing, and the methods that published writers use are as varied as the books that they produce. I would like to think that if you are starting out to write a novel you will follow the advice I have given in the preceding pages and that it will lead you to success, but I have to say that, at every point, you must make your own decisions. Trust in your instincts. There is no magic key, no sure-fire formula. All I can do is to offer a little help along the way. Take my help when you need it, discard it at other times, and believe in your own abilities.

P.S. You may like to know that *Mario's Vineyard* was moderately successful. It was translated into French, Norwegian and Danish. The English edition did not, alas, make the bestseller lists, and it is now out of print. It is, however, still obtainable from many libraries, where it has been constantly in fairly heavy demand ever since it was published.

Recommended Reading

Becoming a Writer by Dorothea Brande (Papermac)
Writing a Novel by John Braine (Eyre Methuen)
Aspects of the Novel by E.M. Forster (Penguin)
The Craft of Novel-Writing by Dianne Doubtfire (Allison & Busby)
The Craft of Writing Romance by Jean Saunders (Allison & Busby)
Writing Crime Fiction by H.R.F. Keating (A. & C. Black)
The Way to Write Science Fiction by Brian Stableford (Elm Tree Books)
Research for Writers by Ann Hoffmann (A. & C. Black)
The Guinness Book of Names by Leslie Dunkling (Guinness Books)
From Pen to Paper by Pamela Frankau (Heinemann)
Reader's Report by Christopher Derrick (Gollancz)
Approaches to Writing by Paul Horgan (The Bodley Head)
The Making of a Novelist by Margaret Thomson Davis (Allison & Busby)

Books by Michael Legat

Writing for Pleasure and Profit (Hale)
The Nuts and Bolts of Writing (Hale)
How to Write Historical Novels (Allison & Busby)
An Author's Guide to Publishing (Hale)
Dear Author ... (Allison & Busby)